RTOWN

Geoffrey Farmer

Brian Jungen

Euan Macdonald

Myfanwy MacLeod

Luanne Martineau

Damian Moppett

Shannon Oksanen

Kevin Schmidt

Curated by Reid Shier

Published by The Fruitmarket Gallery, Edinburgh
in association with the Contemporary Art Gallery, Vancouver

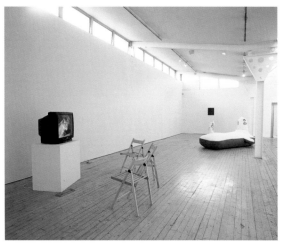

Hammertown, installation view, The Fruitmarket Gallery
5 October to 23 November 2002
Photo: Alan Dimmick

"Once – and this is something he had never done for anyone and would never do again – he showed her the puzzle he was reassembling that fortnight: it was a fishing port on Vancouver Island, a place called Hammertown, all white with snow, with a few low houses and some fishermen in fur-lined jackets hauling a long, pale hull along the shore."

GEORGES PEREC,
Life, A User's Manual (1978)

HAMME

SPONSOR'S FOREWORD

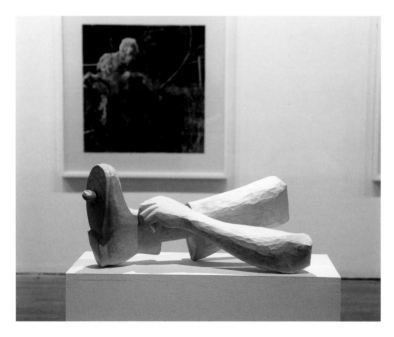

Myfanwy MacLeod,
Our Mutual Friend
(foreground) and
Damian Moppett,
Untitled (Heroic Tertiary)
(background), commissioned
as part of *Hammertown*
Photo: Alan Dimmick

As a continuation of its support for artistic endeavours, Standard Life Investments is delighted to support this major exhibition of newly commissioned art presented by The Fruitmarket Gallery, Edinburgh. *Hammertown* heralds the emergence of a new generation of Canadian artists of exceptional calibre, and is the first comprehensive and thematically related exhibition of their work to be realised outside Canada.

Standard Life has had a presence in Canada since 1834, and is the only mutual company of any significant size operating there. As in the United Kingdom, we are committed to supporting culture in communities where our customers and staff live and work. Standard Life is one of the largest private employers in Edinburgh, and we are aware of our responsibility to be a good corporate citizen. It is particularly gratifying that the *Hammertown* tour begins in Edinburgh, where Standard Life Investments is also based.

Standard Life Investments endeavours to create an excellent environment for employees and visitors to its offices. In recent years it has supported a large number of contemporary artists. By bringing the worlds of art and business closer together we hope to show that more stimulating working environments can be created.

An important part of the sponsorship has been the collaboration between Standard Life Investments, The Fruitmarket Gallery and Arts & Business to produce an innovative education programme. Community groups have had the opportunity to meet the artists and learn media techniques in order to devise promotional campaigns with the aim of persuading their peers to visit the exhibition. This activity has received funding under the Arts & Business New Partners scheme in recognition of this unique collaboration.

Finally, in the words of Reid Shier, the exhibition's curator, "They (the artists) attempt dialogue and point towards relationships that are collaborative and invitational". I hope that you will enjoy the creative dialogue that these artists have started, and join me in thanking The Fruitmarket Gallery for bringing the exhibition to the United Kingdom.

Sandy Crombie
Chief Executive, Standard Life Investments

THIS LAND IS YOUR LAND

Michael Turner

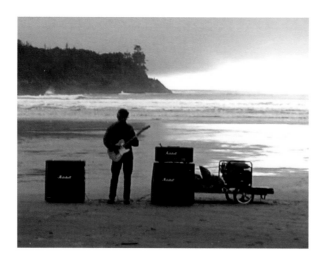

It is a scene familiar to many British Columbians. Forested bluffs overlook a pounding surf, the first glow of sunrise reflects off a wet sandy beach, an ocean vista extends the width of the Pacific. The west coast of Vancouver Island, just south of Tofino, probably Long Beach. Maybe you've seen the brochure: "Visit 'Supernatural' British Columbia". But that was years ago, the old government, the one that promoted Vancouver as a place where you could ski and sail (all in the same day!) before taking a float plane up the coast to watch whales.

Standing in the centre of Kevin Schmidt's video, *Long Beach Led Zep* (illustrated opposite), are two Marshall cabinets, six feet apart. A guitar lies atop one of the cabinets, an amp head on the other. To the right, a portable gas-powered generator. A figure appears, dressed in gumboots and Gortex. He gives the generator a yank and instantly the engine is competing with the surf. He flicks on the amp head and picks up his guitar, slinging the strap over his shoulder. He takes a pick from his pocket and begins.

As familiar as the surrounding landscape is to British Columbians, Schmidt's A-minor arpeggio is familiar to millions more. We can name that tune in four notes. The song is Led Zeppelin's "Stairway to Heaven" (1972), at one time hailed as the greatest rock song ever. For those born in the 1960s, "Stairway To Heaven" was a party staple, a coming of age make-out number that, admittedly, makes more sense now than it did then. Re-reading it I can't help but see it as a metaphysical response to Bob Dylan's "Like A Rolling Stone" (1965), considered by many the lead-off song for The Sixties and arguably his greatest hit.

"Like A Rolling Stone" is Walt Whitman on amphetamines, a rollicking experiment in blues, folk and rock recorded off-the-floor in two takes. It is urban and raw — a litany of angry

recriminations that can't wait to pass judgment. "Stairway To Heaven," on the other hand, was recorded at a time when rock was being 'refined' into metal; when Sixties youth culture, having revealed itself to be just as hypocritical as those it condemned, embraced its contradictions or fled the city to start anew, in places like British Columbia's west coast. Structurally, "Stairway" has more in common with Blake and Wagner than Dylan's pentatonic rocker – its drug is mushrooms, its landscape pastoral, its mood a form of escapist melancholy unknown to Dylan's confrontational New York City. "Like A Rolling Stone" would sound absurd performed on the west coast of Vancouver Island. "Stairway To Heaven" doesn't.

"Stairway" works on the strength of a single guitar part ("Like A Rolling Stone" is ensemble-driven); and no matter what note the guitarist is playing, the listener knows exactly where they are in relation to the song's obtuse yet unforgettable lyric. Everyone familiar with "Stairway" can quote at least a couple of lines. And what do those lines point to but "trees" and "brooks" and "songbirds"; the sun rising and falling; wandering, mystery, intrigue:

> And if you listen very hard,
> the tune will come to you at last.
> When all are one and one is all,
> to be a rock and not roll.

An artist performing "Stairway to Heaven" on a deserted beach on Vancouver Island. It sounds incongruous at first, a parody, the subject of a Dylanesque reproach. But there is harmony to this image. Waves crash at the right moments, and the absent lyric is made all the more present by the backing landscape. (Like I said, you see "trees" and hear "songbirds"; it is "dawn.") But as his fingers journey over the fretboard, they begin to wander. Mistakes are made. And Schmidt's pose is anything but heroic: he clings to his instrument as if dowsed by a rogue wave.

Long Beach Led Zep is either a child's first recital or a lunatic's last hurrah. Which, I'm not sure. But one thing I do know is this: the song is not out of place. As for the performer, well, I think that's just the point.

*

At thirty, Kevin Schmidt is the youngest of the eight artists in *Hammertown*, all of whom are Canadian and, with the exception of the peripatetic Euan Macdonald, reside on the southwest coast of BC, mostly in Vancouver. At least half the group would identify sculpture as an important part of their practice. Yet some of those sculptors might say the same about drawing and video, just as those who work in video might say the same about drawing and sculpture. Half have exhibited photographs. Most have exhibited in more than one medium.

Landscape figures strongly in the work of these artists. So does space, the availability of which distinguishes a younger west coast from an older, more storied east, perhaps accounting for the monumental scale in which many of these artists have been working. Further to that I would add an interest in social, aesthetic, and technological histories. Finally, if I were to go out on a limb, I would concede that enough of them are curious about childhood to make it a topic of discussion.

In a recent issue of *public*[2], guest editor Christina Ritchie evokes Philip Aries on the historical construction of childhood in Western culture, identifying childhood as a marker for "profound transformations to social structures, moral values and systems of production." Ritchie goes on to say that, "as one of the few experiences we all share, childhood is a ready magnet for whatever neuroses and insights we [as artists] wish to project." Indeed, it is this shared experience that has provided the framework in which many younger artists (from the digital designers to the 'neo-folk' essentialists) are currently working, "remind[ing] us of the tremendous powers of observation... children seem to possess." But what I find most relevant in Ritchie's "Introduction" comes later, where she mentions the way that artists interested in the concept of childhood "assert the continuing value of play as a means of self-discovery and insight. For the most part they commend as virtues those traditional attributes of childhood – weakness, imbecility, irrationalism, and amorality – that were, in the past, used as arguments for its discipline and disparagement."

More than any artist in the show, Schmidt's *Long Beach Led Zep* meets Ritchie's four virtues. There is "weakness" (flubbed notes), "imbecility" (he could have been electrocuted), "irrationalism" (the beach is no place for high-volume electrical equipment), and "amorality" (people are sleeping!). In terms of point-of-view, we are reminded of the child's "tremendous powers of observation" by virtue of the camera's fixed position: the camera, like the child, does

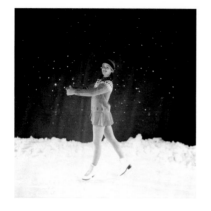

little more than stare (considered rude when I was young), so the spectator could not possibly be an incredulous adult – not for seven minutes! Only a child could stare for that long. Only a child could be frozen for seven minutes.

The child's point-of-view is also apparent in Shannon Oksanen's *Spins* (left). Like Schmidt's *Long Beach Led Zep*, the camera remains fixed as we watch a teenaged figure-skater perform a succession of dance moves (but no jumps) on a set consisting of shoveled snow and twinkling stars. The film is a silent loop, shot in high contrast black-and-white, and recalls the early days of cinema. However, it is not the skater that first attracts us but the gaze. The skater is someone the child admires, someone they want to be when they grow up. Unfortunately that's as close as they'll get, for there is too much distance between the camera and the skater, reinforcing the notion of the skater as ideal, a music box figurine come to life. But the viewer's spatial distance is only half of it; the other half is temporal. Because the audience for this piece is adult, we are reminded of our own failures (to become figure skaters) by virtue of our advancing age. That is one reading. Another concerns Oksanen's interest in moments where emerging forms cohabitate with those entrenched, only to distinguish themselves through new technologies and specific languages. The most obvious example is motion picture film, which began by recording theatrical performances from the perspective of the theatre audience. With the advent of multiple cameras, zooms, cutaway shots and editing, less (and more) was expected of the actor. Soon, motion picture performances became focused not on the theatrical audience but on the men behind the lenses, the movie-makers who, after a day's shooting, would take these performances and stitch them together behind closed doors. It is no wonder, then, that the term 'movie magic' still has resonance: one of the earliest film pioneers, George Méliès, was a magician.

Spins is reminiscent of an earlier video work by Oksanen called *Compulsory Figures* (1999, opposite, top). This video also depicts a skater, who, unlike the skater in *Spins*, is still a child. And whereas the former is performing an ice dance in perfect silence, the latter (her skates scraping and scuffing) is practicing her compulsory program – a series of prescribed movements skaters are accountable for when in competition. What both pieces have in common, however, is the

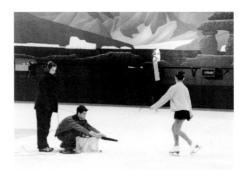

theatrical background. While *Spins* uses the night sky, the backdrop in *Compulsory Figures* resembles an Inuit rock sculpture atop a figurative landscape painted by one of the Group of Seven (a group of Canadian painters who are recognized as our country's original Moderns). At first, the landscape seems at odds with the younger skater's routine, for what is she doing but carving out pure forms – circles and figure-eights. When I first saw *Compulsory Figures* my reading of it was very different from my reading of *Spins*: because then it was the skater's routine and its relationship to the landscape I was interested in, not the gaze.

As a fan of competitive figure skating I have despaired the decision by television networks to stop their coverage of the compulsory program. The explanation for this (I phoned the network) was based on the perception that compulsories are boring and that viewers are only interested in the more animated (read: entertaining) dance program. However, the real reason, according to a friend who works in television, is that broadcasters had trouble providing excitable commentary for something as rigidly formal as the compulsories. Indeed, this tension between so-called boring formal exercise and the more animated dance program parallels one of the central tensions in the popular history of art: this notion that art should be lively and colourful, our artists bold and exuberant. (The same can be said about rock 'n' roll, which Schmidt effectively subverts with his rote performance of "Stairway To Heaven.") But I'm sure there are many of us who would enjoy listening to commentators animate compulsory programs, much in the same way many of us enjoy reading Donald Judd's pathologically descriptive art reviews of the work of Dan Flavin.

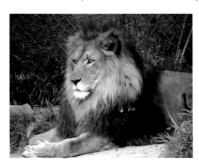

Euan Macdonald's *Two Lions* (2002, left) employs the fixed-position camera as well. *Two Lions* is also about looking – in this case, at a lion (and occasionally a passing lioness). We see the first lion in repose, and we seem to be looking at him for a very long time. The absence of sound (which

Oksanen uses to similar effect in *Spins*) only intensifies the relationship between viewer, gaze, and subject, and it is not long before we stop asking questions of what we are seeing and respond to the lion's periodic movements with narratives of our own. As children we might remark on how unhappy the lion is, a first indication to our parents that they raised us to be compassionate (isn't that the real reason we take children to zoos?). Which leads us back to questioning: we presume this lion is in captivity because of a chain link fence behind him. Nevertheless because his presence fills the frame via the artist's zoom lens, the nature of his captivity is vague – perhaps it is this: a camera focused on his every move, his privacy blown out of proportion, his status as 'King of the Jungle' ridiculed. What of the lioness? She inserts herself between the camera and her mate. She seems pissed off, as if she doesn't like us looking at him. Or maybe she's hungry? With all these readings, there are many more lions than the two we've been looking at. Even if there were only one lion we could still call this video *Two Lions*.

Macdonald's *The Shadows Path* (2001, illustrated page 45) plays with time in a different way. This video follows a shadow as it retracts with the setting sun over a bucolic countryside. An aerial shot, we begin in mid-flight, and it takes a moment for our eyes to adjust. Once they do we notice that the video has been slowed down, as evidenced by the strobing texture of the image. Indeed, it is through this process of slowing down that a tension is created, as in a childhood nightmare, where the faster you run, the farther back you go. It's an anxious feeling, one that leads me to ask more of the point-of-view: because now, with the slow-motion effect, it appears as if the camera is not so much tracking a shadow but looking for something, much like we are looking for something when viewing the Zapruder film[3]. Surveillance comes to mind, as do conspiracy theories involving spy cameras on commercial flights. Yet this is a pastoral landscape, and surveillance cameras are usually seen as urban. Once again we are reminded of the ostensible incongruities contained within *Long Beach Led Zep* and *Compulsory Figures*. And again what seems like an incongruous pairing is quickly contradicted. As the aircraft prepares to land (it is a helicopter) we see the swirling grasses below, an appropriate abstraction given the remarkable tension Macdonald creates by playing mechanical speed against solar time.

In an exhibition where moving images and sculpture dominate, the work of Damian Moppett provides a hinge. His images are still photographs, while his latest models (making their debut in catalogue form – opposite, top) are not so much sculpture as architectural maquettes. Like Macdonald, Moppett is interested in landscape and social control – most recently, a historical

representation of the pastoral known as the 'kermis', a 16th-century bacchanal undertaken by European peasants at the end of harvest. Moppett's exploration of the kermis appeared two years ago, in a work entitled *Peasant Dance* (after Rubens, who was among the first to paint the kermis from the peasants' point-of-view). *Peasant Dance* consisted of a series of location snapshots taken near Los Angeles' Chinatown district paired with a written treatment for a film, to be based on the kermis. Accompanying the sequence was Moppet's own recreation of Ruben's famous painting, illustrated below. (Earlier this year Moppett extended the kermis project, recreating a new series of Rubens paintings, but also introducing an architectural model of a skateboard park). With this new work, which includes a selection of goat photographs (and as-yet-unfinished tree fort models), Moppett appears to be pushing his project further towards abstraction.

Having established a relationship between historical and contemporary models of social control (the kermis was sanctioned by paternalistic landlords, while the skateboard park is the city's official alternative to skateboarding on public amenities), Moppett has set his sights on the particulars of his source material. With the kermis paintings, the artist has activated tertiary characters such as goats, which Rubens employed as symbols animating the carnal passions of his human subjects, recasting them in lead roles for *Hammertown*. But these are not goats Rubens might depict; these are goats photographed just before shearing. Although in most of Moppett's photos we recognize these creatures by their horns, eyeballs and muzzles, they are, in the extreme, anonymous woollen tangles, abstractions, more like bathmats than anything evocative of sexual congress (indeed, if they were further removed from their pastoral setting

we might be tempted to think of them as just that). Abstraction can also be found in the models of skateboard surfaces Moppet has installed in trees. What looks like a skate ramp only looks that way, perhaps less so because of its context. Like the skater who uses his board as a medium of physical graffiti, Moppett has taken the sanctioned (though now abstracted)

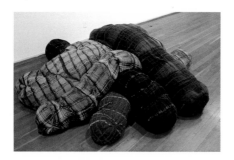

boarding surface and conformed it to nature, reversing the relationship architecture often occupies when it imposes itself on the landscape.

Like Moppett's goats and tree forms, and the skaters and landscapes in Oksanen's film and video, Luanne Martineau is interested in social and aesthetic relationships, specifically tensions between realism and abstraction. However, unlike Moppett, who uses an art historical referent from the 16th century to parallel a contemporary phenomenon (skateboarding), Martineau's work, like Oksanen's, focuses on history's overlaps and in-betweens. Martineau uses popular media to create hybrid works that attempt to reconcile the perception of realism as inherently socio-political, while Abstraction, as an aesthetic advance within Modernism, apolitical.[4] Drawing on *The Yellow Kid* comic-strips of 19th century cartoonist R. F. Outcault, which had as its object the Irish American working-class immigrant, as well a skit from the 1950s television program *Your Show Of Shows*, Martineau traces the institutionalization of racism and working-class hatred in contemporary North American media.

Knitted Accumulation Sculpture (2001, above) is a recent work of Martineau's which refashions plaid patterns from *The Yellow Kid* cartoon using an antiquated knitting machine. The resulting fabric is employed in the creation of large, stuffed tubular pillow-like shapes. When displayed these soft forms, built from acrylic and mohair, resemble both a tartan shit heap and Modernist sculpture. In *The German General* (illustrated page 54) Martineau has created a styro-stuffed sculpture based on a skit from *Your Show of Shows*, where a fussy, almost childish German man (played by Sid Caesar) is dressed by his beleaguered valet who scrambles to see that the 'general's' whims are met. As with most sketch humour from the period, the punchline inverts what we think we've seen into its opposite: the 'general', it turns out, is nothing but a lowly hotel doorman.

Martineau's *The German General* is not so much a portrait of a stereotypical German receiving his come-uppance as a landscape where attitudes towards race and class are played out. Remnants of the skit are to be found in the piece. The band of colour at the foundation of the sculpture is battleship grey, the same colour Hugo Boss used when designing the uniform of Nazi infantryman. As for the off-white surface where buildings are represented as both flaccid

and semi-erect, that seems obvious, given that any discussion of Nazism and, in the case of *The Yellow Kid*, the plight of the Irish (as the "niggers of Europe"), invariably evokes questions of racial purity and physical and intellectual superiority.

Martineau works to similar effect with graphite and onion-skin drawings. An ongoing project that began with tracings made from cartoons the artist later recycled into collages, Martineau begins (again) by layering one image over the other to create varying degrees of density and distortion. Once completed, Martineau crops her collages to conform to a square-frame format. In her latest drawings, *The Four Seasons* (2002), we see what resembles a series of landscapes. Shacks and tree stumps, old barrels and barbed wire, window frames and Modernist sculpture. In the middle of *Fall* (above) is an explosion, the word GLOMP issuing forth (onomatopoeia being the best abstraction we have for the language of sudden impact). Yet these drawings are not abstractions, nor are they the abstract backgrounds we might associate with a Daffy Duck cartoon; they are too dense and layered, and there is too much figuration going on 'inside' them. Indeed, these drawings are somewhere in-between Ashcan School and Abstraction, a palimpsest, a socially-conscious lyric rooted in narrative figuration. Working backwards from the finished image we see that Martineau's drawings began not as a performative action based on a semi-conscious emotional state but as clear-headed exercises in the formation of foundational narrative. This peeling back of the onion skins, so to speak, reminds us of the cumulative effect jokes like *The Yellow Kid* and *The German General* have: how, after repeated retellings, in numerous social contexts, comedic forms abstract to form the basis for a generalized attitude that is imposed upon those being 'othered', in an effort to bolster who 'we' think we are. This, I believe, is what Moppett is getting at with his architectural models.

At first glance, the drawings and sculpture of Myfanwy MacLeod appear to have much in common with the work of Martineau, for MacLeod too is interested in cartoon, television and movie references. However, MacLeod opts for a more literal approach (in the Swiftian sense), using an odd combination of monumental scale, weight, and minimalism to impress upon the viewer the gravity of what's bugging us.

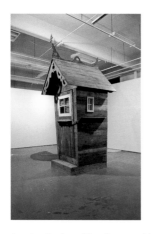

Of the artists in this exhibition, MacLeod was the first to work with large format sculpture. Earlier works such as *My Idea of Fun* (1997, illustrated page 50), based on a fiction by English writer Will Self, featured a man's head inflated to gigantic proportions, with a hole in the back big enough to accommodate even Self's wildest dreams. (As with much of MacLeod's work, the pyscho-political nature of this piece is personal – yet the subject of local lore!). Last year MacLeod simultaneously unveiled two thematically-linked works at two local galleries. The first, entitled *The Tiny Kingdom* (2001, above), was a full-sized outhouse modeled on the one featured in the children's classic *Chitty Chitty Bang Bang* (1968); the second, *Miss Moonshine*, showcased a series of drawings that (like Moppett) elevated the hillbillies in John Boorman's 1972 film *Deliverance* to star status. Although something bad in us recognizes an amity between hillbillies and outhouses, the better part knows that the sources for these works come from entirely different contexts: the hillbillies are from the 1972 American South, and the outhouse, which is Victorian in design, is from England. Yet this is the point: what MacLeod shows us is not the spatial and temporal equivalent of mixed metaphors, but two places out of time within their own social and historical settings. In *Deliverance*, the rural hillbillies are living in a world so old it might as well be the past; in *Chitty Chitty Bang Bang* an adventurous family belong to a past so fantastic it could well be the future. That the hillbillies and the family are so at odds with the civilizations they are confronted with parallels an anxiety many younger artists are faced with today: an art world that appears increasingly compacted and inbred.

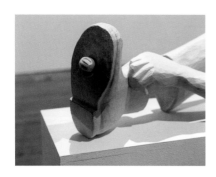

MacLeod's latest work marks a return to her preoccupation with satire and disembodied parts. Using yellow cedar recycled from an old WELCOME TO WEST VANCOUVER sign (West Vancouver is Canada's wealthiest municipality), MacLeod has fashioned a human-scale gesture – one hand pulling on a boot, a toe caught in the sole – to create *Our Mutual Friend* (illustrated left). The title, of course, refers to Dickens's satirical novel, where a man of

despicable nature, Silas Wegg, goes to great lengths to buy back his amputated leg – not to 'regain himself' but to put a stop to the leg's accruing value as a 'monstrosity'. MacLeod's interest in body parts is also evidenced in a work entitled *Sausagefinger* (1996, illustrated page 46), which consists of a series of Polaroid photographs the artist shot of her hands, each finger sporting a monster pork sausage. Here, what initially appears to be a poke at the (romantic) notion of 'the hands of the artist' and the (fetish) objects they are said to 'create' quickly turns grim. For these are ghastly images, made even ghastlier by the Polaroid's deficiencies as a film format, its inability to distinguish between human flesh and sausage meat. Indeed, the work takes on a new and horrific layer given recent local events: the remains of at least seven bodies which were discovered at Robert Pickton's Lower Mainland pig farm. Even more recently, the revelation that these bodies, believed to be among the 73 women who have disappeared from Vancouver's downtown eastside over the past twenty years, may have been mixed in with pig parts and sold to a local sausage manufacturer.

While MacLeod's work has scaled down (for the moment), Geoffrey Farmer's work appears to be getting bigger. *Trailer* (2002, below) is the principal component in an ongoing project entitled *The Blacking Factory* (after another Dickens story, this one concerning the author's impoverished childhood, where he was forced to work in a shoe polish factory). *Trailer* is a life-sized shipping trailer, the kind we associate with film and television production. Everything needed to transform a landscape or an actor into a filmic subject is contained within these trailers – which, for the past twenty years, have become a regular feature on British Columbia's roads and highways, as many Hollywood companies have been using the province as a cheap backdrop for America's towns and cities (the Canadian dollar is currently worth 63 cents US). However,

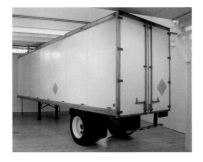

unlike Hollywood's trailer, Farmer's *Trailer* carries with it social issues. Despite having real wheels and a welded steel frame, *Trailer* is something of a sham – or to use film parlance: a prop. The viewer need only look underneath to see that its walls are veneer, its rivets plastic. In its first exhibition, *Trailer* was accompanied by two additional works. *A Box With The Sound Of Its Own Making* (2002), after Robert Morris, is a projected video FX sequence showing the gallery's imploding exterior. *Daily*

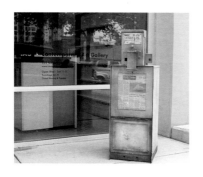

Times (2002, left) is a newspaper box (also a film prop) positioned outside the gallery entrance, where the newspaper headline screams THE FUTURE BECOMES REALITY above a story (dateline: 1980) of a bullet train linking San Diego with Vancouver.

A Box With the Sound of It's Own Making and *Daily Times* provide insight into *Trailer*. Farmer's work has always drawn attention to the gallery system. Morris' own box, filled as it is with the sounds of hammering and sawing, echoes the concerns many of the Hammertown artists have with pure forms and their inability to carry notions of social class (as we saw earlier with the work of Martineau). *The Blacking Factory* was originally shown in Vancouver's Contemporary Art Gallery. Here one got a sense of how *Trailer* challenges the authority of the white cube (it is bigger than any of the gallery's entrances and exits). *Trailer* also alludes to Farmer's previous work, such as *The Hunchback Kit* (2000), a portative trunk that contains everything one might need to stage *The Hunchback of Notre Dame*. The kit is constructed such that it provides opportunities to stage conceptual dialogues with the venue of its exhibition.

Brian Jungen has distinguished himself recently with two 'life-sized' right whale skeletons, fabricated out of hundreds of plastic chairs, like those you find at Wal-Mart (*Shapeshifter*, 2001, below). Jungen has an uncanny eye for transforming extant forms into what we associate as their opposites, and like Farmer, he also utilizes the contexts in which his work is shown. *Prototype for New Understanding* (1998/1999, illustrated on pages 32-33) saw Nike trainers (shoes made by children, for children) reconfigured into Northwest Coast masks similar to those we see in museums. Recently, Jungen's work has moved from the figurative to the abstract. Works such as *Untitled* (2001, illustrated page 36), a stack of shipping pallets made of expertly finished Western Red Cedar, convert the pallet from disposable carrier to precious art object. In a more recent piece, *Void*

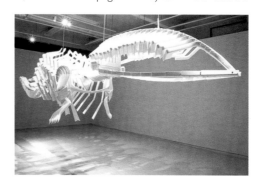

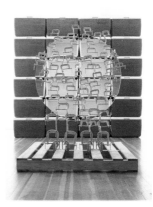

(2001, right), a light beam projected through a free-standing C-clamp structure reminiscent of Inuit rock sculpture (or is it a Lawrence Paul Yuxweluptun figure?), casts ovoid-shaped shadows onto a circular surface cut from a wall of Coleman coolers. A sophisticated piece, *Void* evokes the cave in Plato's 'Republic' while alluding to civilization's effect on First Nations cosmology.

For *Hammertown*, Jungen manufactures another work from a Coleman cooler. This new work turns away from Native iconology toward a colonial model. Jungen has, in much of his practice, refocused an anthropological lens back upon cultures for which cultural exploration is a one-way street. European and North American societies are used to looking, not being looked upon. In *Beer Cooler* (illustrated pages 38-39) Jungen co-ops motifs of tattoo art, biker gangs, and white trash culture to emblazon an object of middle-class wilderness retreat. It is stocked (free for the taking for gallery visitors), with beer, much as it might be on a typical camping trip. The cooler, in this guise, harkens back to an object of West Coast Native art: cedar plank chests that were meticulously fashioned and elaborately painted with emblematic symbology. At the same time, the chest is opened to offer back, as a gift, one of the most devastating of European imports to North America.

<p style="text-align:center">*</p>

In a recent essay on the work of Mexican painter Gunther Gerszo, Cuauhtémoc Medina writes:

> *Instead of representing the Aztec phantoms, Gerzso explored the modern subject's fear at the unreachable historic depth of Indian culture. He provided an account of modernism which involved sublimating the horrors of modernity in a strict formal order. This "system of allusions" to the experience of cultural incommensurability could only be available to a surreal/modernist.*[5]

I offer this quote not to claim that the artists in this exhibition are 'surrealists' (although I suppose a case could be made for it) but to draw attention to the need younger and emerging artists have in developing strategies for dealing with, among other things, the weight of the

landscapes in which they live. Earlier I mentioned the "Supernatural" British Columbia tourist campaign. What I didn't mention was how uncomfortable many of us were with this campaign. Yet we endured, despite the consequences, putting up with questions like "Why does it rain all the time? It's not raining in the brochure" at every turn. I also mentioned the Group of Seven painters, how their work, much of it completed before the Second World War, persists as 'official' Canadian Art, and is the standard by which many Canadians continue to judge contemporary production. Another concern is our current government's willingness to forsake the natural landscape in favour of oil and gas revenues, concurrent with stalled land-treaty negotiations with First Nations people – a strategy that will keep Natives from sharing the rewards. These are consequences artists in Canada live with on a daily basis. There are many different conceptions of land and landscape operating in the country, and I think this is reflected in this exhibition.

The four videos in *Hammertown* all say something about landscape. Schmidt struggles with it in *Long Beach Led Zep*. The skater in Oksanen's *Spins* performs against an idealised night sky whose magical quality is now evidently transparent. Of the two videos provided by Macdonald, both the lions' natural landscape as well as their artificial landscape is removed and assumed; while in *The Shadows Path*, the landscape is not so much a surface for a retracting shadow but an object of scrutiny. With the sculptural works, Moppett's take on the municipal skateboard park as a model of social control has more in common with Macdonald's zoo than a place for fun and play. Martineau's *The German General* makes landscape out of portraiture, while her landscape drawings assume a topography based on their method of construction. MacLeod's sculpture alludes to landscape through her choice of materials and their source contexts. Farmer's *Trailer*, like those ubiquitous film and TV trailers, becomes a defining feature of both our interior and exterior landscapes. Jungen's cooler defines a landscape of colonisation and subjugation.

These practices are, in my opinion, as diverse as the economies that have evolved from Canada's 'official' beginnings as a country rich in natural resources. Of course I could be wrong. In fact, given that governments and corporations are becoming increasingly occult in their public and private practices, I would not be surprised if a raven were to arrive at my window one evening and, like "the songbird who sings," quoth a little Led Zep: "sometimes all of our thoughts are misgiven."

FOOTNOTES

[1] Gaddis, William, JR (Penguin: New York), 1975, p. 3

[2] Ritchie, Christina, *public* 21, Toronto, 2001, p. 7

[3] The Abraham Zapruder home movie of the assassination of President John F. Kennedy in Dallas in 1963 is the only known film of the entire assassination. It is a silent, 8mm colour record of the Kennedy motorcade just before, during and immediately after the shooting. The two major investigations into the assassination, the Warren Commission in 1963-64 and House Select Committee on Assassinations in 1977-78, relied on it to answer questions about how the shooting happened, and it is often played in extreme slow motion.

[4] MacLeod, Myfanwy, *Lubberland* (Stride Gallery, Calgary), 2001

[5] Medina, Cuauhtémoc, Gerzso: the indoamerican gothic, Tate Modern webcast, 2002

Geoffrey Farmer

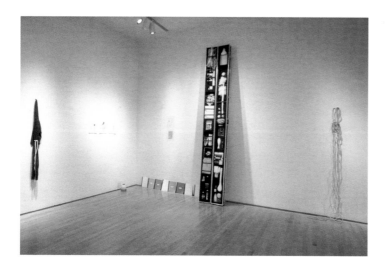

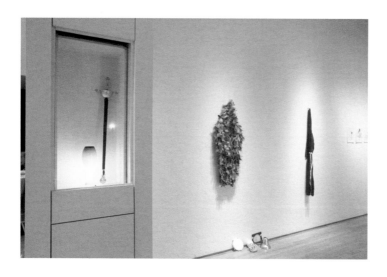

Hunchback Kit, 2000
Installation view,
Art Gallery of Ontario
Crate, lights, electrical cords,
drawings, research
documents, monitor, VCR,
videos
Dimensions variable

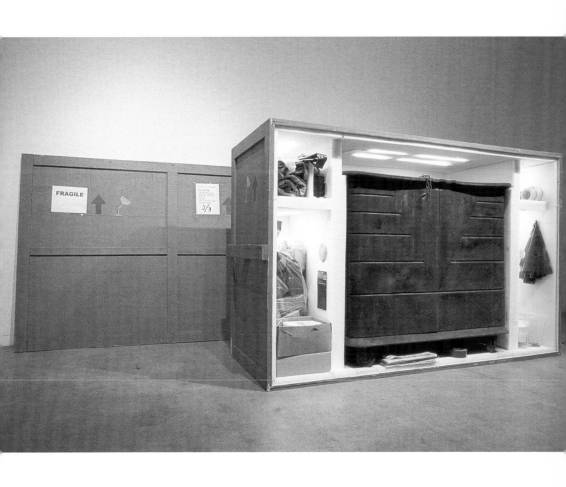

... And Finally the Street Becomes the Main Character, 2001
Installation view, Plug In, Winnipeg
Crate, various media and video
Dimensions variable

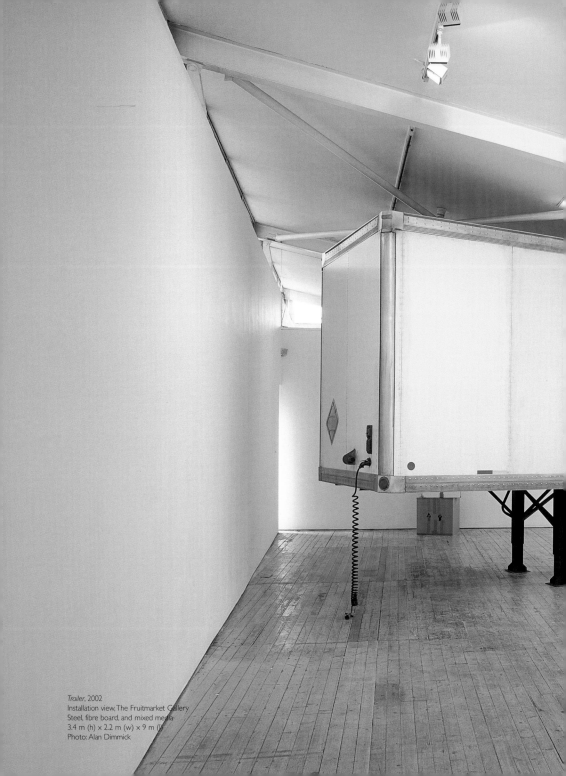

Trailer, 2002
Installation view, The Fruitmarket Gallery
Steel, fibre board, and mixed media
3.4 m (h) × 2.2 m (w) × 9 m (l)
Photo: Alan Dimmick

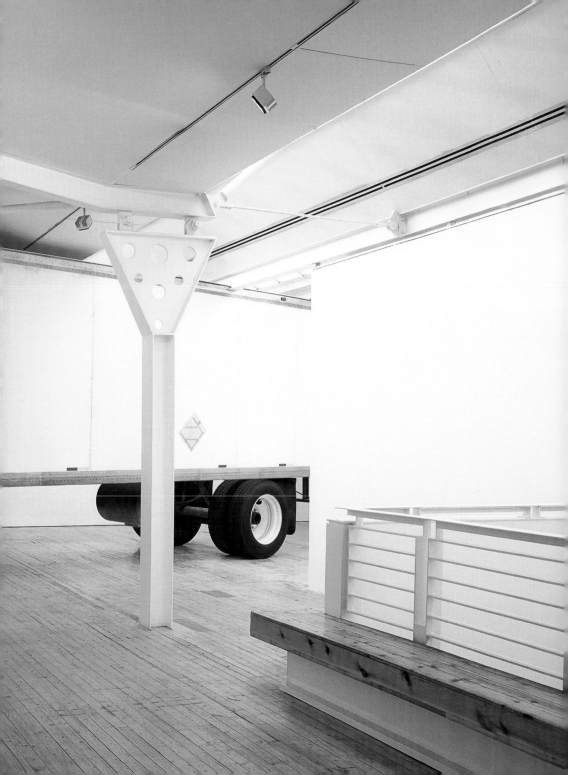

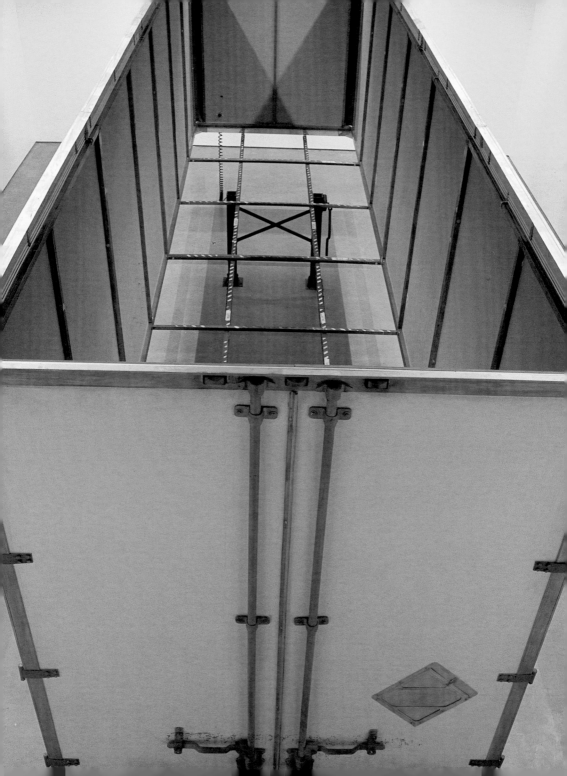

Opposite: *Trailer*, 2002
Dimensions/media as before
Above: assembly of *Trailer*
Contemporary Art Gallery, Vancouver, 2002

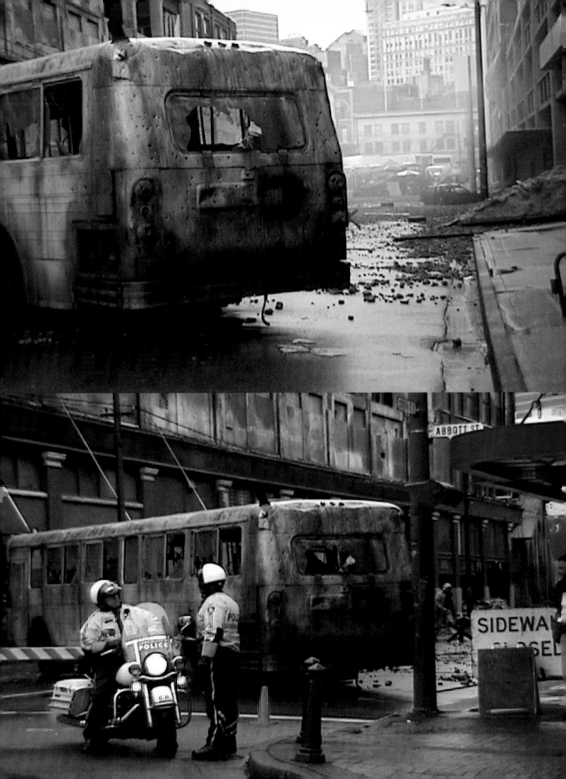

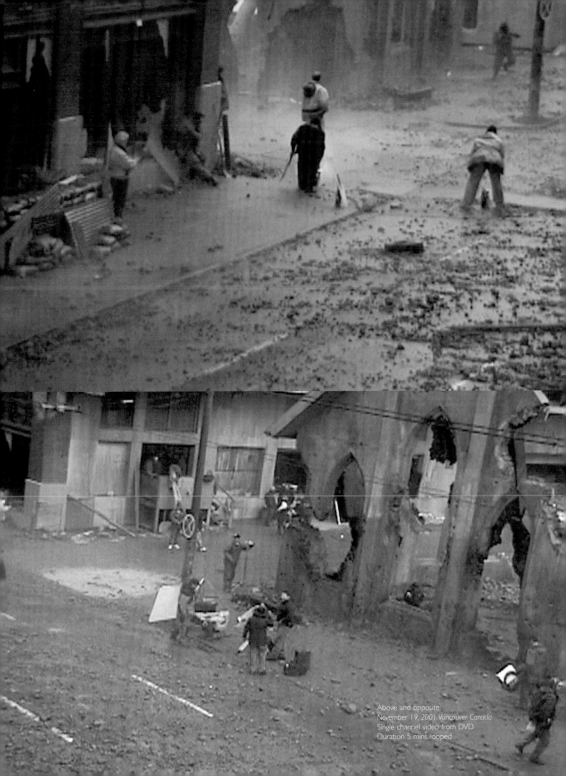

Above and opposite:
November 19, 2001 Vancouver Canada
Single channel video from DVD
Duration 5 mins. looped

Brian Jungen

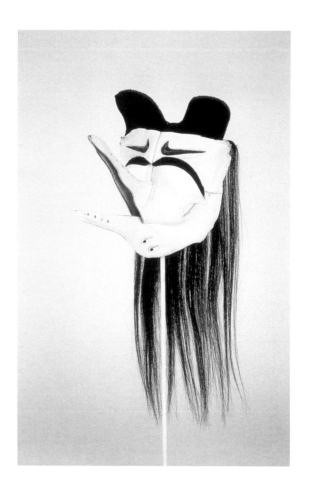

Left: *Prototype for New Understanding No. 2*, 1998
Nike Air Jordans, hair
9 × 9 × 18"
Opposite: *Prototype for New Understanding No. 8*, 1999
Nike Air Jordans, hair
19 × 22 × 10"

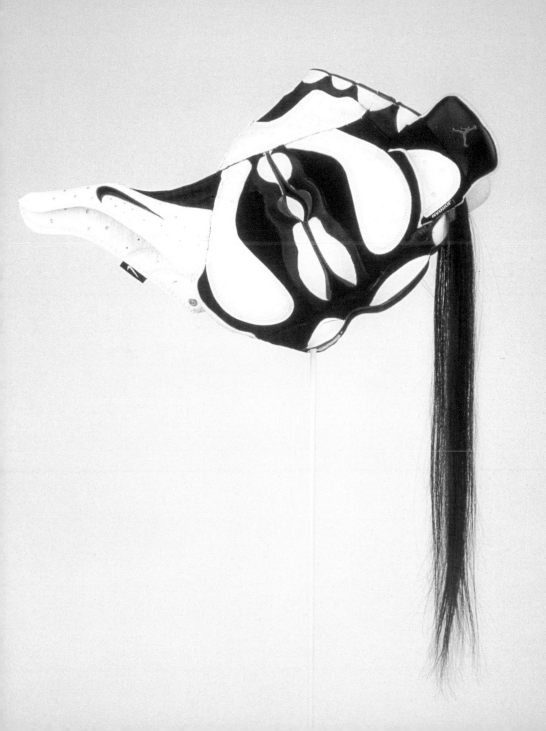

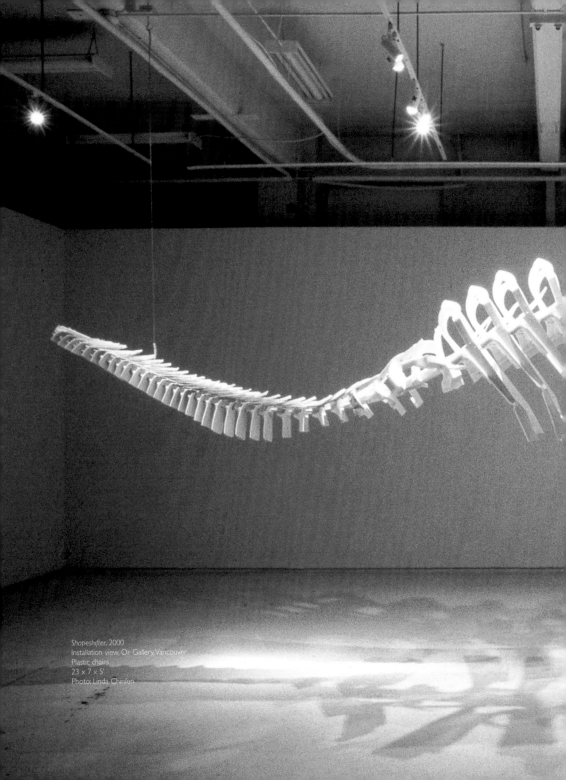

Shapeshifter, 2000
Installation view, Or Gallery, Vancouver
Plastic chairs
23 × 7 × 5'
Photo: Linda Chinfen

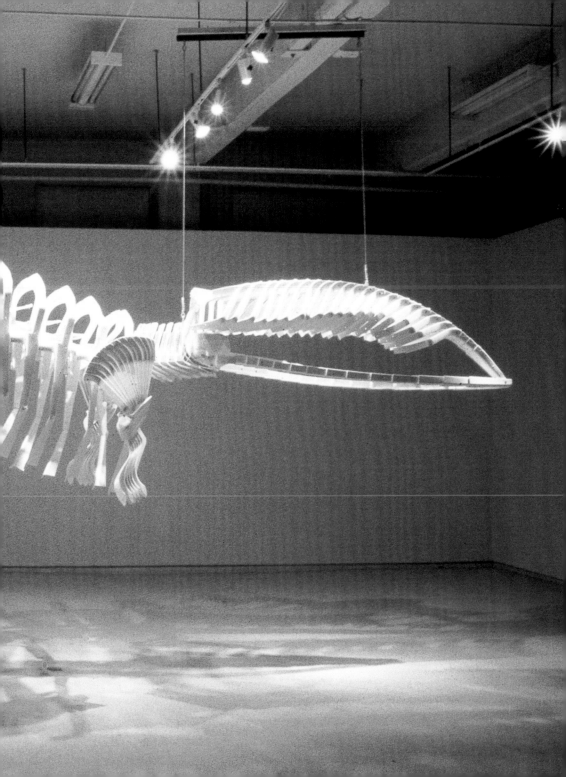

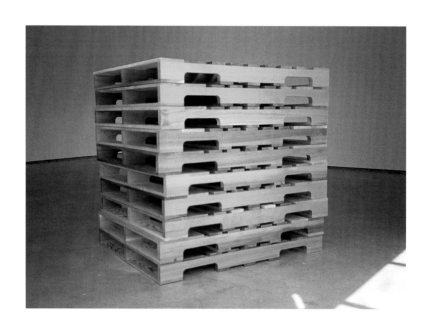

Top: *Untitled*, 2001
10 red cedar pallets, archive
46 × 47 × 40"
Bottom: *Vernacular*, 1998-2001
Graphite, ink and watercolour
on paper
40 × 52"
Opposite: *Void*, 2001
Picnic coolers, c-clamps,
shipping pallet, spotlight
Dimensions variable

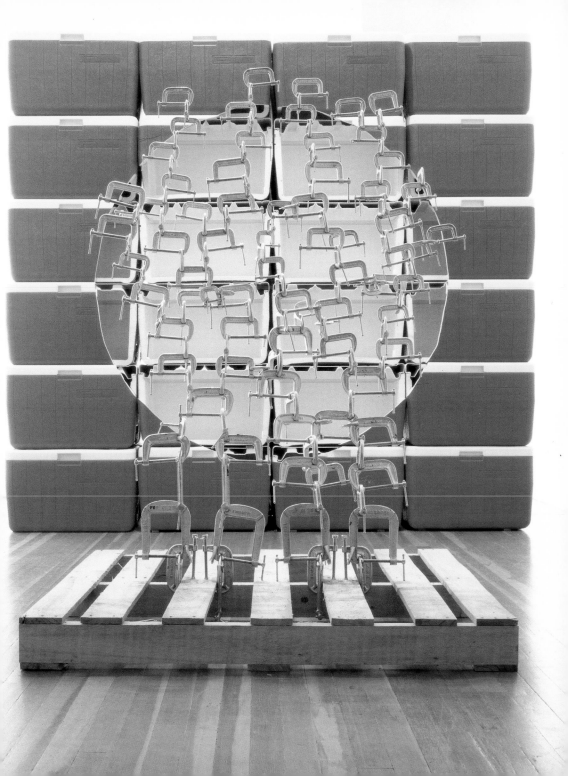

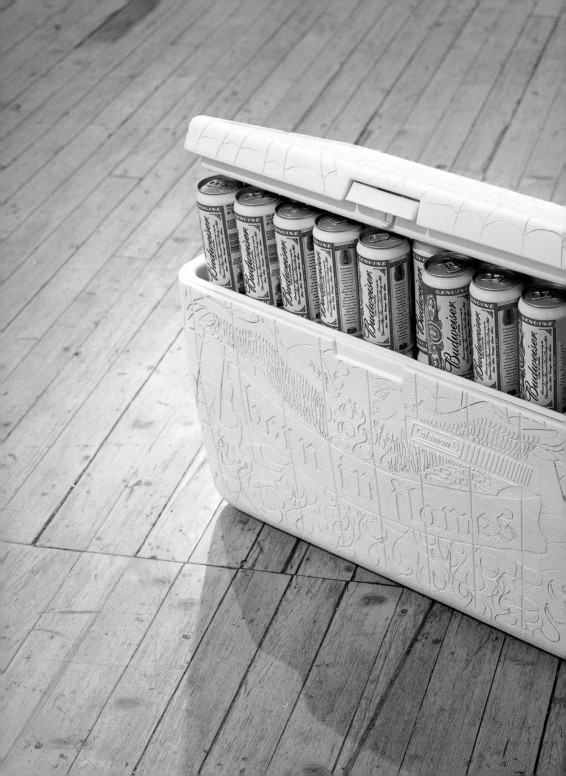

Beer Cooler, 2002
Installation view,
The Fruitmarket Gallery
Picnic cooler, beer cans
40 × 70 × 40cm
Photo: Alan Dimmick

Euan Macdonald

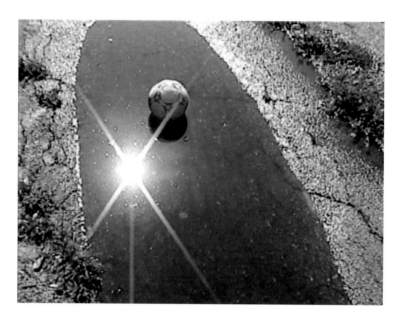

Top: *Untitled*, 2000
Video, duration 2 mins
Bottom: *Hammock*, 2000
Video, duration 2 mins

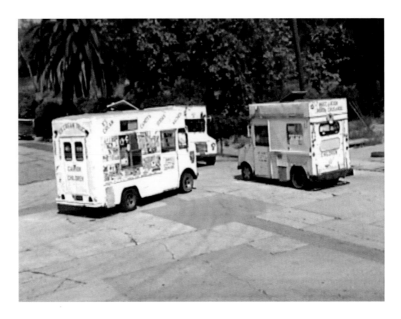

Top: *Three Trucks*, 2000
Video, duration 2 mins
Bottom: *Two Planes*, 1998
Video, duration 2 mins

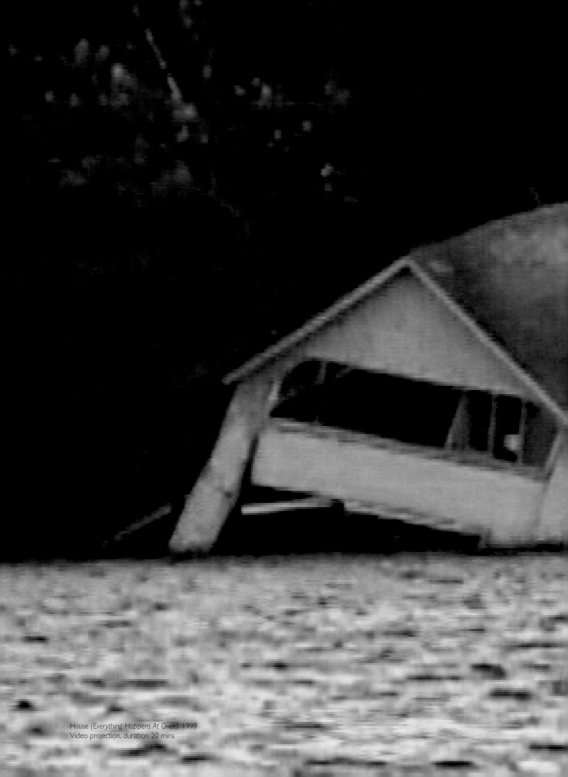

House (Everything Happens At Once), 1999
Video projection, duration 20 mins

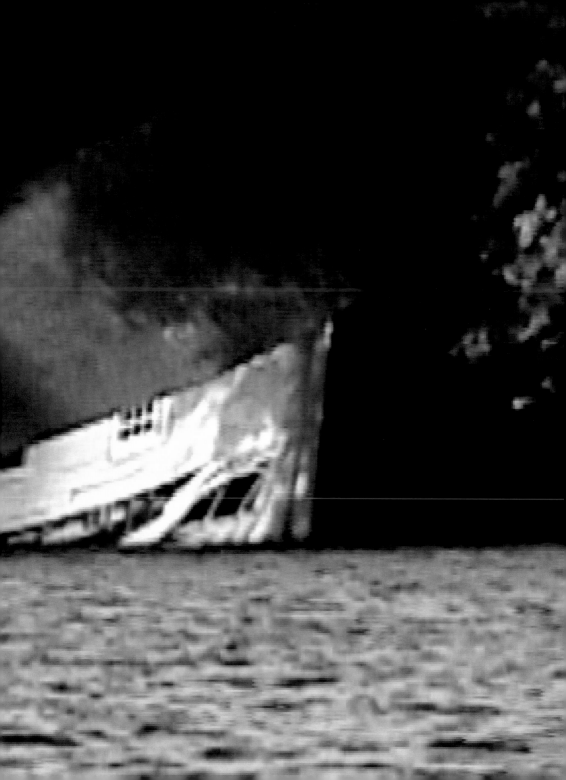

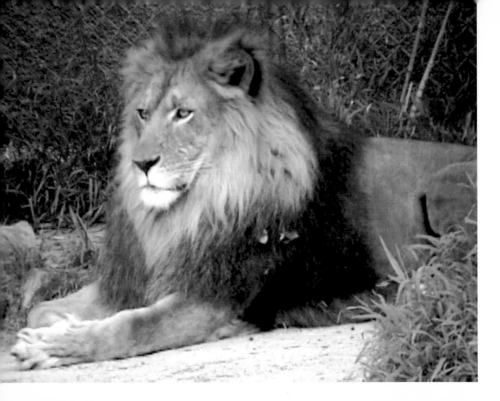

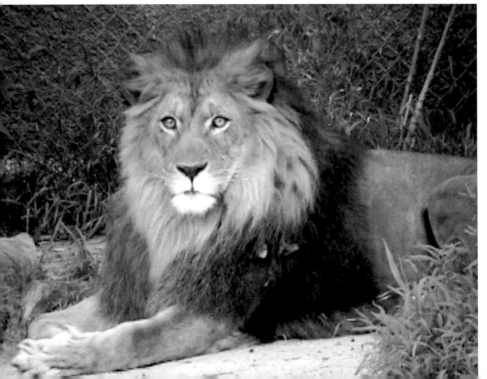

Two Lions
2002
Single channel video
from DVD
Duration circa 5 min

The Shadows Path
2002
Single channel video
from DVD
Duration circa 5 mins

Myfanwy MacLeod

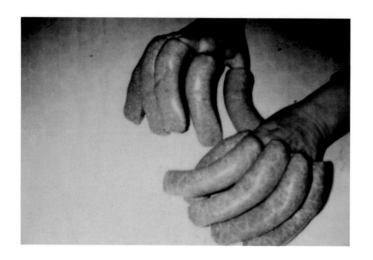

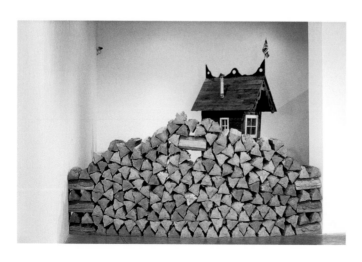

Top: *Sausagefinger*, 1994
Polaroid Photograph
4 × 3"
Bottom: *Wood for the People*,
2002 (foreground) and
The Tiny Kingdom, 2001
Installation view, The Power Plant,
Toronto
Cement, wood
Dimensions variable
Photo: Cheryl O'Brien
Opposite: *The Tiny Kingdom*, 2001
Installation view, Or Gallery,
Vancouver
Wood and mixed media
14 × 4 × 4'

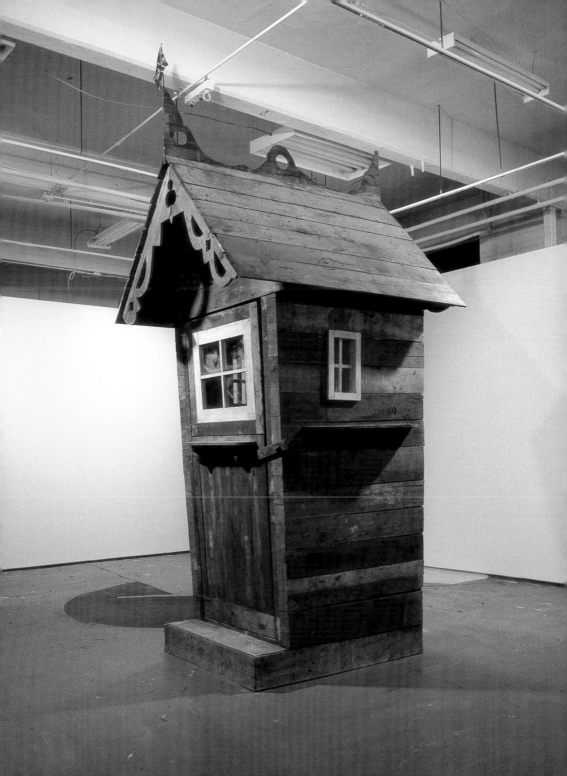

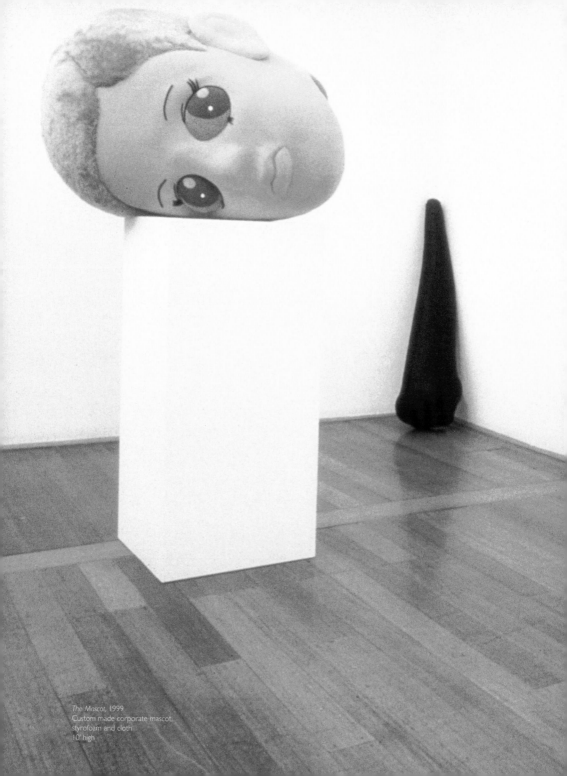

The Mascot, 1999
Custom made corporate mascot,
styrofoam and cloth
10' high

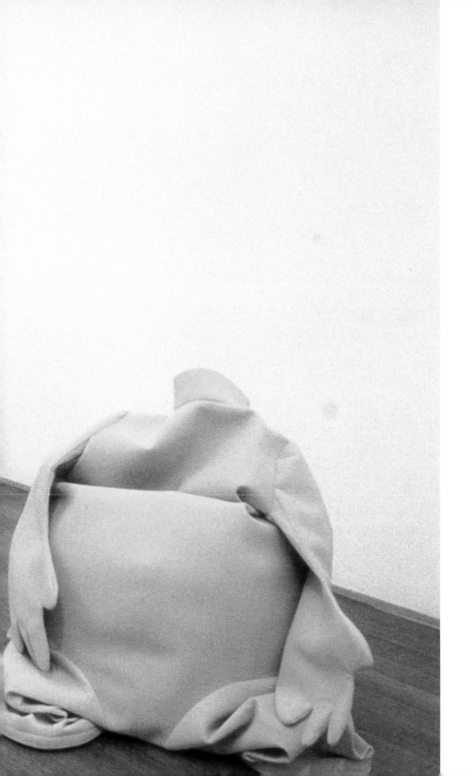

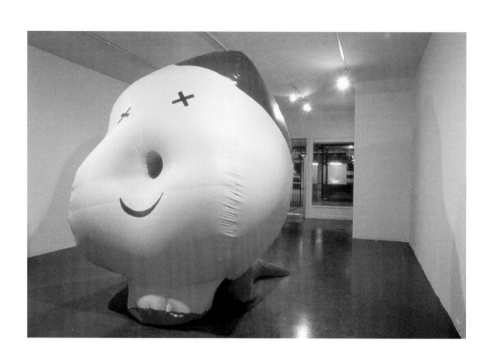

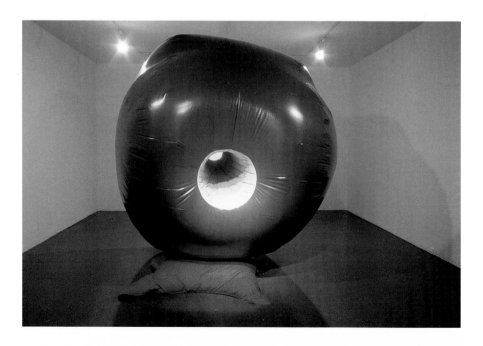

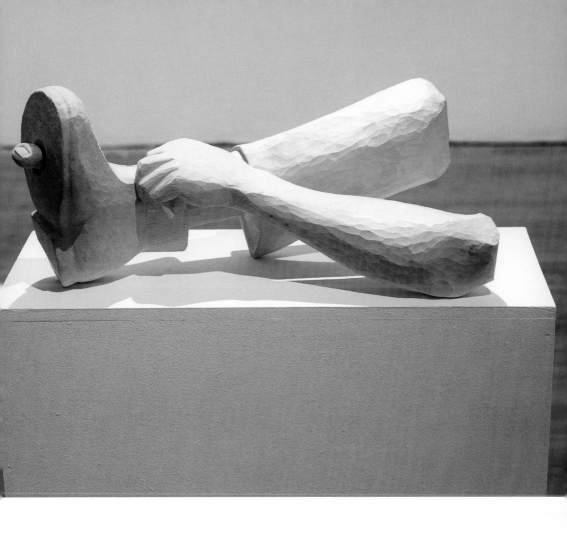

Opposite: *My Idea of Fun*, 1997
(front and reverse view)
Custom inflatable with fan unit
14 × 14 × 11'
Above: *Our Mutual Friend*, 2002
Installation view, The Fruitmarket Gallery
Wooden carved sculpture
24" (h) × 10" (circum.)
Photo: Alan Dimmick
Right: Study for *Our Mutual Friend*, 2002
Graphite on vellum
18 × 12"

Luanne Martineau

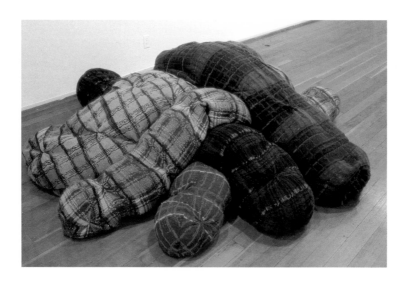

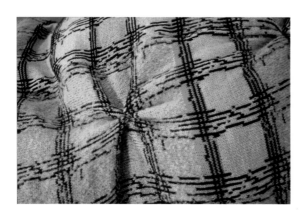

Knitted Accumulation Sculpture, 2001
(and detail)
Mohair, synthetic wool, stuffing
popcorn
5 sections, size varies

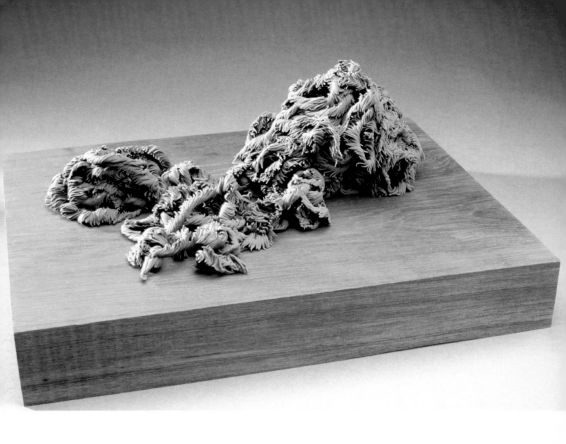

Accumulation Sculpture No. 3, 2000
Femo on teak
5 x 11 x 15"

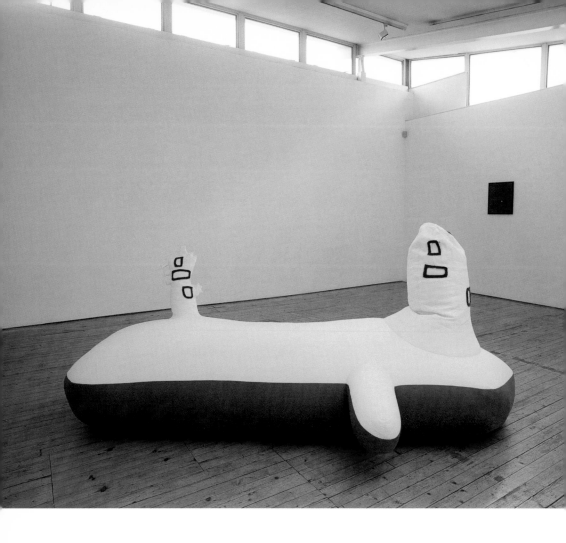

The German General, 2002
Installation view, The Fruitmarket Gallery
Felt, mohair, fabric, styro-beads
4 x 3.5 x 9 feet (approx)
Photo: Alan Dimmick

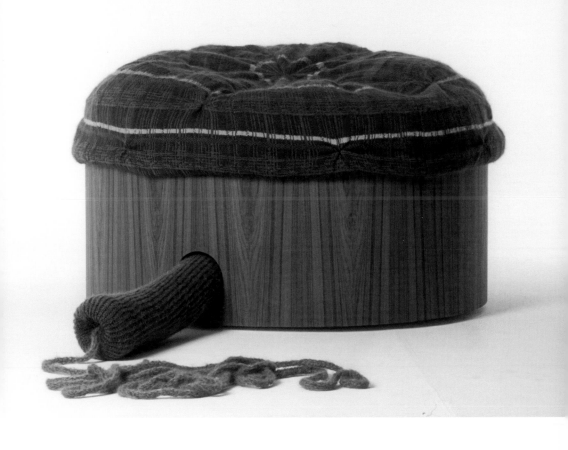

Knitted Factory Form, 2001
Mohair, synthetic wool, teak veneer, wood, stuffing
1.5 × 4 × 4'

Opposite, top: *Summer*
Bottom, left: *Winter*
Bottom, right: *Spring* (detail)
This page, top left: *Fall*
Top right: *Spring*
Middle left: *Fall* (detail)
Middle right: *Summer* (detail)
Bottom right: *Spring* (detail)
All 2002
Graphite and collage drawings on onion
paper
Spring, Summer, Fall each 13.4 × 17.2"
Winter 9.1 × 12"
Collection of Russell Baker

Damian Moppett

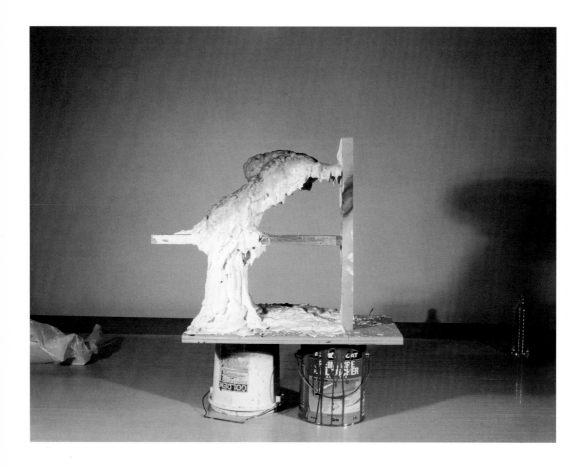

Above: *Worm in Studio (Back)*, 2000
Fuji crystal archive print mounted to board
48" x 54.5"
Right: *Endless Rustic Skateboard Park (Bacchic Peasant Version)*, 2002
Photo: Cheryl O' Brien
Installation view, The Power Plant, Toronto

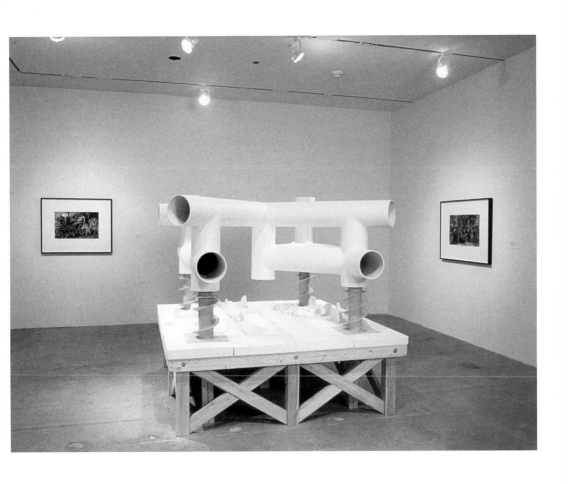

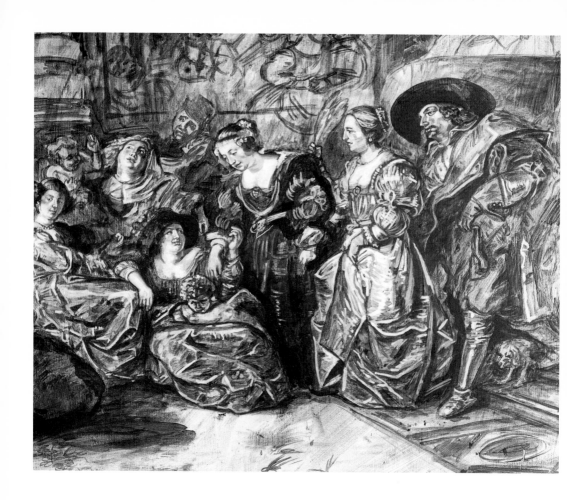

Above: *The Garden of Love (After Rubens)*, detail, 2002
Oil on paper
18 x 32"
Opposite: *The Fall of the Damned (After Rubens)*, 2002
Oil on paper
30 x 22"

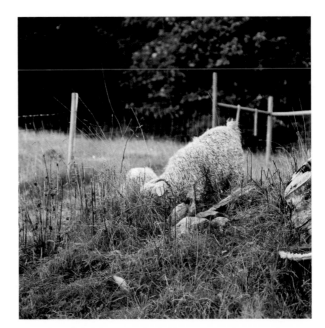

This page and opposite:
Untitled (Heroic Tertiary), 2002
Fuji crystal archive print mounted
to board
Each 48" x 48"

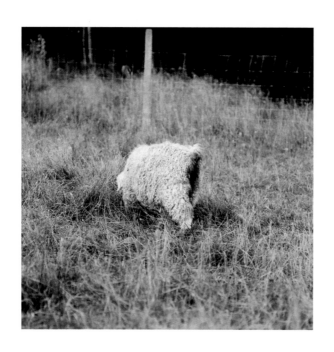

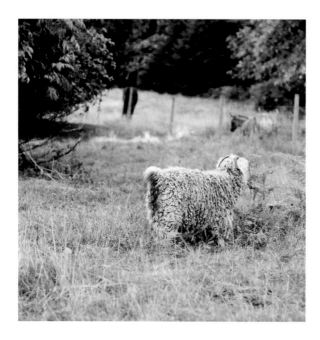

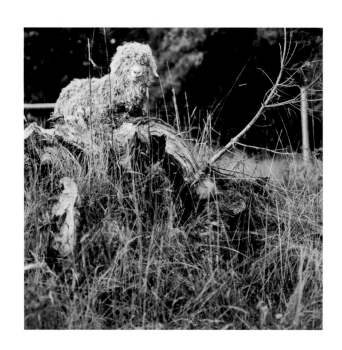

This page and opposite:
Untitled (Heroic Tertiary), 2002
Fuji crystal archive print mounted
to board
Each 48" x 48"

Shannon Oksanen

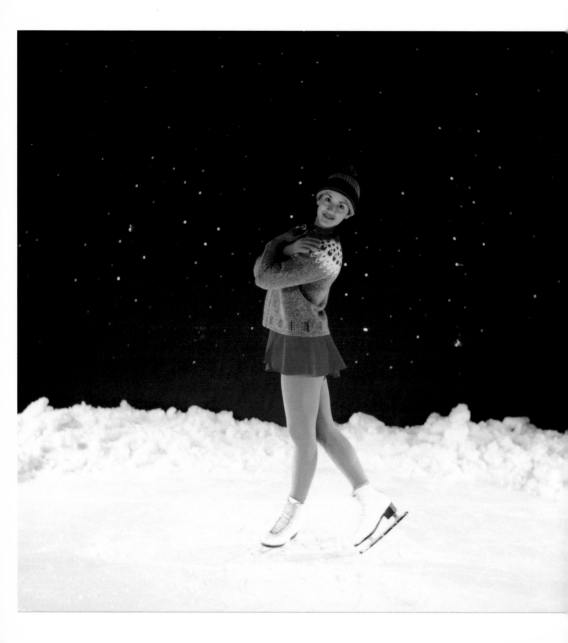

This page and opposite: *Spins*, 2002 (production stills)
16mm film projection, duration 3.5 mins
16mm film, looper mechanism, 16mm film projector
Photos: Scott Livingstone

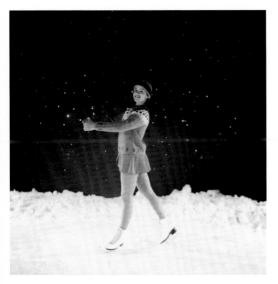

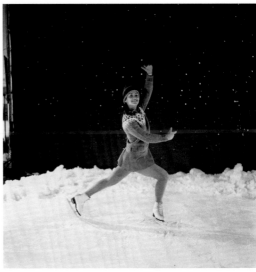

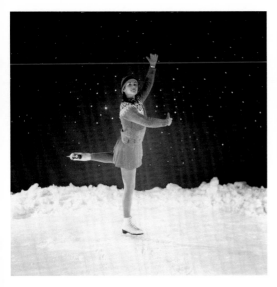

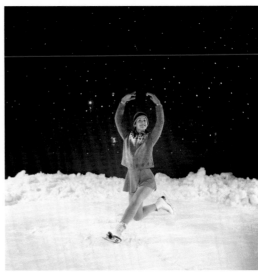

Production still from *Spins*, 2002
Details as before

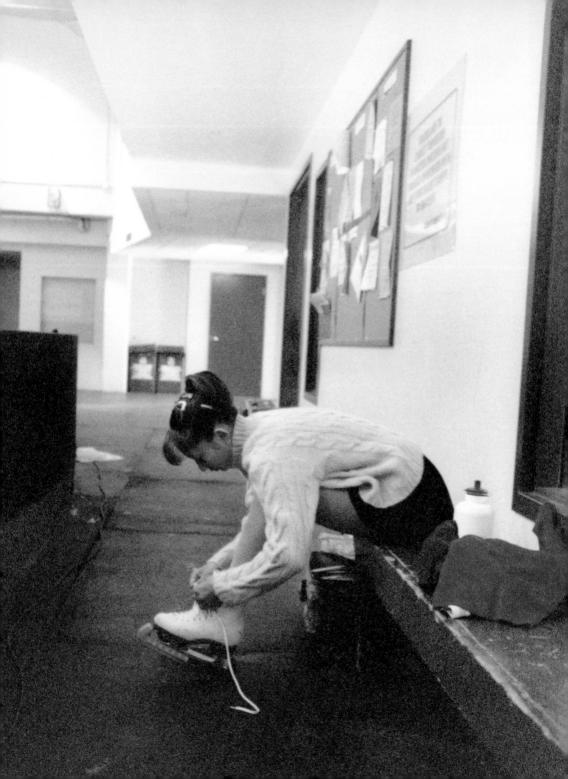

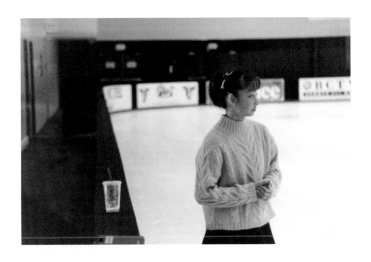

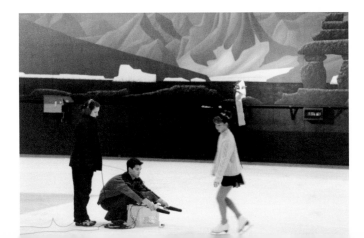

Compulsory Figures, 1999
(production stills)
Video
Photos: Rodney Graham

Clockwise from top left:
Nana Mouskouri No. 3, Nana Mouskouri No. 8,
Nana Mouskouri No. 2, Nana Mouskouri No. 9
All 1999, graphite on paper, each 13 x 13''

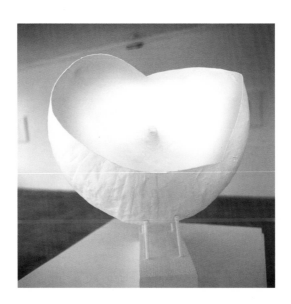

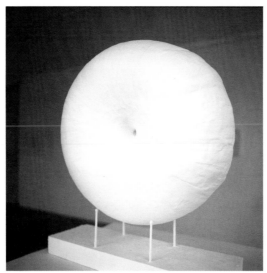

Top: *Torus No. II*, 1999
Bottom: *Torus No. I*, 1999
Papier-mache, wood and acrylic paint

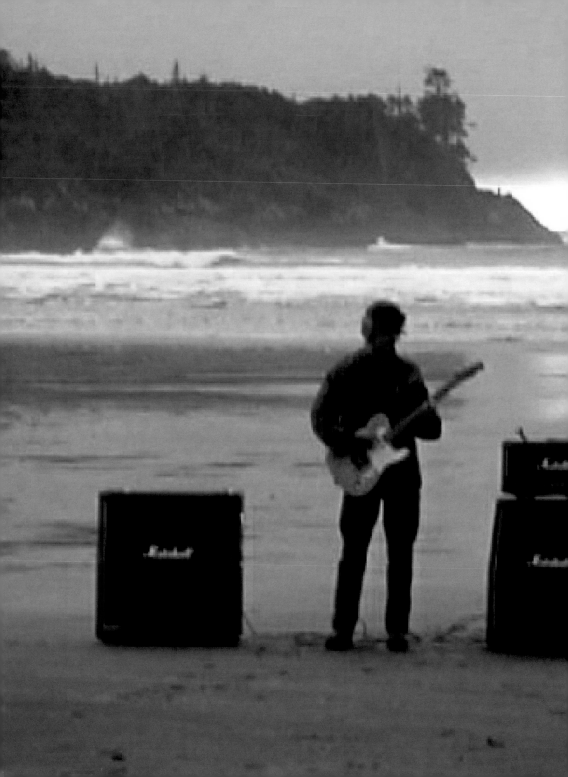

Long Beach Led Zep, 2002
Single channel video from
DVD
Duration 10 mins, looped

HAMMERTOWN

Reid Shier

for Peter and Daphne

South Wellington survey photograph, 1943
Courtesy of BC Archives
Call no. I-64274

The Backlot

On February 10, 2001 *The Vancouver Sun*, the city's daily newspaper, ran the word 'STARS' across the top of its front page. Inside each of the letters were faces of Hollywood personalities like Richard Dean Anderson, local notables such as K.D. Lang and Sarah McLachlin, and other minor celebrities. Two pages in the lead section of the paper detailed the "invasion of the rich and famous", explaining "why British Columbia is becoming the perfect spot for celebrities to buy homes". Between speculation that such A-list talent as Michael Douglas and Arnold Schwarzenegger had been "rumoured" to own property in BC, the paper detailed how John Travolta once rented an apartment while making a film here, and that Gillian Anderson, Jean Claude Van Damme and Joe Lando, "who starred in Dr. Quinn, Medicine Woman" had actually purchased homes in the city.[1]

This journalism is axiomatic of a type of star-struck reportage prevalent in Vancouver at the moment. The cheap Canadian dollar is a can't-not-buy for American film and TV production companies, and the inequity between the two currencies means 'runaway productions' flood north out of Los Angeles into Vancouver, Toronto and Montréal. The three Canadian cities have become major stages for features, movies-of-the-week and episodic TV drama series. Larger productions employ well known Hollywood talent, and a gossip column appears daily in *The Sun* itemizing local celebrity sightings. It's titled, aptly but uncritically, 'The Backlot'.

What is peculiar to Vancouver, however, as distinct from towns or cities hosting the occasional location film shoot, is that stars have on a daily basis and for the past number of years continued through town. The movie, so to speak, hasn't left, and *The Sun*'s speculation that some actors might be putting down roots can be looked at with at least a little sympathy. Movie stars are such a fixture of Vancouver's streets, it is hard not to imagine a few liking it here enough to want to stay. The reality, for many civic boosters, can be deflating. The heated overreaction to actor David Duchovny's offhand joke on the David Letterman show in 1997 that Vancouver was a "nice place, if you like 400 inches of rain a day" is a case in point. For many Vancouverites, fantasies of American stars buying local real estate is a guilty pleasure that assuages a nagging, provincial self image. Raising civic deficiencies can be criticized as spiteful, but nevertheless points acutely to a city whose main status is as a resource town for industries with a head office elsewhere. In this atmosphere, Duchovny's unsuspecting comment hit a raw nerve.

The Island

Vancouver Island lies just off the southwestern coast of British Columbia, about 35 miles from Vancouver across the Straight of Georgia. The island's western beaches face out to the Pacific and support an active board culture. The waves are not the caliber of California, Hawaii or Australia, but are good enough. According to one local surfer (with typical Canadian humbleness), one beach near Ucleulet is rated "17th best in the world." The eastern half of the island is distinctly different. Protected by a small mountain range running down the island's spine, the dryer leeward side has Canada's most temperate climate. Its winters are mild (with little snow and no need for fur) and there's not too much rain in the summer, so it is neither cold nor really wet, and thus feels neither Canadian nor Coastal. It is set within the perimeter of a large natural basin that is one of the most naturally productive regions of the world. Prior to first contact the area supported one of the densest populations on the continent.

According to a recent theory, there's a good chance Sir Francis Drake's *Golden Hinde* touched down on this eastern shore sometime in the late summer of 1579.[2] To date, Richard Haykluyt's account of Drake's voyage has been taken on faith, and the northern point of the pirate's plundering journey up the Americas has been assumed to be off the coast of California, near present day San Francisco. No one considered that the Elizabethan records might be carefully contrived forgeries intended to fool Spanish spies. By reconstructing inconsistencies in his logs, and retracing maps made after his return, a local historian speculates that Drake made it as far as Alaska, which would place Europeans in the waters of present day BC centuries before the accepted first sighting in 1774 (of the islands of Haida Gwaii) by Spaniard Juan Perez. As late as 1920 Nanaimo Indian elders were only too keen to relay stories about Europeans pre-dating Perez and Cook by hundreds of years, but few historians paid much attention.

If Drake's visit is confirmed, the secrecy around it may have been driven by his belief he'd discovered the western entrance to the fabled Northwest Passage. On his return to England he told Elizabeth he'd found "a short way home". While the location of this shortcut is unclear, it was on Vancouver Island, north of Nanaimo, that Drake claimed 'New Albion' for his Queen. His plan was to build a fort and shipyard to serve as a base for plundering the Spanish coastal colonies, but more crucially to guard the entrance to one of the most priceless bits of colonial real estate ever discovered. By the turn of the 17th century the few Drake may have entrusted

with his secret were dead, and with them went any knowledge of an entrance to the hoped-for route back home. For the next two and a half centuries, as England and Spain vied for title over the land and waters of the West Coast, the inside passage between Vancouver and the mainland remained hidden, and it wasn't until Cook's midshipman George Vancouver entered the Straight in 1792 that Europe rediscovered this purported gate to the east.

Tree and leaf

Victoria, BC's provincial capital, is on the southern tip of Vancouver Island and has the air of a colonial backwater (it is often described as a city that's more English than England). Nanaimo is the island's other main city. It sits half way up the eastern side, and its distinct character results from a history as a working class resource town. Friends of mine live just south of Nanaimo in the small town of South Wellington. The name's imperial air speaks of the town's early British immigrants and of an area whose first large population in the late nineteenth century was expatriate Scottish miners. At the time South Wellington was the centre of a short-lived, booming coal industry, but the coal was so depleted and gaseous that by the beginning of the twentieth century the miles of veins snaking under the streets and along the coast – even under the ocean – were abandoned, and the miners moved out. Today the only reminders of this industrial past are some overgrown coal tips, which lend picturesque accents to a landscape of unobtrusive rural charm. The area, in fact, looks remarkably like the British countryside, with small hedge-rowed acreages excised from blocks of Douglas fir and blood-barked arbutus trees.

The look of these farms dates back to the era of the miners, who afforded time for their horticultural pursuits by hiring Chinese laborers to do the actual digging underground.

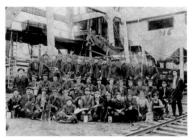

Following a long tradition of colonial exploit, the Europeans paid the Asians a percentage of their own wages – freeing them for days spent on lands purchased with money they kept for themselves. Long after their departure, the area still basks in a tranquil aura at odds with the resource industries that, to this day, form the backbone of the Vancouver Island and BC economy, the proximity of which are often right over the next hill.

South Wellington, Miners of the Morden Mine, 1915
Courtesy of BC Archives
Call no. E-03416

Chief among these industries is the forestry company Macmillan Bloedel (or Mac Blo as its locally known), thanks to whose neighboring Harmac pulp mill South Wellington enjoys the occasional sulfurous odour wafting in from the northeast. Mac Blo's dominance over the BC economy has been waning, however, because of environmental protests targeting the harvest of old growth trees, coupled with recent protectionist duties slapped on our softwood exports by the United States. These setbacks have sped the slipping importance of lumber to the Provincial economy, and sometime in the 1990s the forest industry was probably eclipsed by pot as BC's largest cash crop. Pot's ascendancy is reflected in the staggering number of basement hydroponics 'grow-ops' proliferating across the province (and the increasing expertise of local cultivators), but is also due to it's savvy marketing (largely to the U.S. in exchange for coke), which most suspect is handled by Hell's Angels. The BC chapter is, to no one's surprise, the richest in North America. Hard numbers are impossible, but some speculate the marijuana harvest is pumping as much as 6 billion dollars annually into the province. Whether this is hyperbole, there's no doubt drugs and film production are the green in the green of the BC dollar. "It's a bit of a puzzle" says one economist, stumped by the number of service sector jobs springing up, especially for salespeople in stereo and audio equipment. Pointing out that most aspects of the economy are in decline, including resource industries like forestry, high tech, and tourism after 9/11, the job numbers are, he adds, "a mystery".[3]

It is reason to celebrate for the Hell's Angels, though, and every year they throw a party near my friend's house on the island. It's held in late summer, and Angels come to it from all over Canada and the U.S., filling the brimstone tang of South Wellington's air with the low, hiccupping sounds of their Harley Davidsons. They're on their way to Angel Acres, the bike gang's resort camp, and South Wellington's current claim to fame.

DRIVER: I've got an extra jacket behind the seat, if you want to put it on.
BOBBY: No, it's okay.
DRIVER: Suit yourself. But I'll tell you, where we're headed is gonna get colder'n hell.

South of South Wellington, there's a small restaurant on Highway One. It's an unremarkable café set alongside a gas station, a place I would continue to ignore had not my resident friend Pete pointed out its use as the set in the climactic scene of the film *Five Easy Pieces* (1970). Outside this café, whose fictional location is in the Northwest US state of Washington, Jack

Nicholson's character Bobby Dupea abandons his car, clothes and money and runs away from his pregnant girlfriend, played by (real) Canadian actress Karen Black, hitching a ride on a (fictional) Canadian-bound logging truck.

Dupea's misanthropic escape and flight into the unknown is set in an alienated rural sideway in the middle of backwoods America. The scene is shot by an American film crew on a Canadian location that's substituting for America with characters in dialogue about traveling to a place they are at that moment standing in. Los Angeles artist Cindy Bernard photographed this café and gas bar in 1991 as part of the project of twenty-one photographs entitled *Ask the Dust*. Bernard was recreating landscape shots from American films made between 1954 and 1974, including such classics as *The Searchers* by John Ford, *Vertigo* and *North by Northwest* by Alfred Hitchcock, as well as B movies like *Faster Pussycat! Kill! Kill!* by Russ Meyer. She used information provided by the film's directors and production managers and reconstructed the shot – without the actors – using the same aspect ratio. Bernard's titling is informational and brief, in this case: *Ask the Dust: Five Easy Pieces* 1970/1991. She is vague about the location of her locations, assuming either their unmistakeability, as with the mesas of Utah or the Golden Gate bridge, or their interchangeability, such as in this Van Isle gas station.

Lettuce

In 1790 Don Pedro Alberni sailed into Nootka Sound on Vancouver Island's west coast. It was twelve years after Captain Cook had first touched down in the sound at Friendly Cove, and a year after Alberni's countryman Estevan Jose Martinez had boarded English ships here and nearly touched off a war. The two countries, as mentioned, were sparring over title to the coast, (and with it a lucrative trade in sea otter pelts), and Alberni had been charged with consolidating Spanish authority in the region. He promptly set about building a fort, which included within its garrison a bakery and an elaborate garden (from which a record still stands in BC for the largest head of lettuce ever grown). The Spaniard made friends with Maquinna, the Mowachaht chief at the head of the Nuu-chah-nulth nation, whose land Alberni was on. This friendship was no small feat considering Maquinna's brother Ke-le-cum had recently been shot

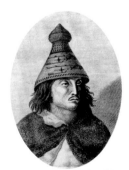

Chief Maquinna, Nootka Sound Indian
Courtesy of BC Archives
Call no. A-02678

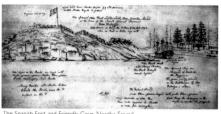

The Spanish Fort and Friendly Cove, Nootka Sound
Courtesy of BC Archives, call no. PDP01329

by a Spanish sailor. Alberni's ambassadorial talent reputedly lay in his gracious hospitality. He began learning to speak Nuu-chah-nulth, and became famous for hosting large, elaborate dinners to which Maquinna, other ranking chiefs, and any other visitors to the region would be invited. Captain Vancouver, for one, expressed admiration for the "superfluity of the best provisions, served with great elegance."[4]

The generosity and warmth in this anomalous tale stand in stark relief to the general historical tack of the West Coast. In 1792 Alberni was transferred back to Mexico, (later to assume the Governorship of California). After his departure, the air of suspicion and mistrust between the Europeans and Natives returned. Spanish sailors are reputed to have systematically raped a number of Nuu-chah-nulth women. If true, it may have been what finally incited the chief, who had endured a litany of injustices by Europeans and Americans.[5] In 1803, an American vessel named the Boston stopped at Friendly Cove to trade. Its captain insulted Maquinna in a language he thought the chief wouldn't understand: English. In response, Maquinna slaughtered the crew, sparing two sailors, one of whom he subjugated as his personal slave.

For the next half century BC was largely abandoned by colonial powers. Then its resources attracted a new generation of fortune seekers: miners, loggers, and fisherman the first of many. The landscape of BC is traced with the intersecting trails and detritus of their use. It is a landscape that is studded, today, with collisions of often surreal contrast, and as Michael Turner suggests in his accompanying text, this is nowhere more evident than in the language used to describe it. Here an image of a clean, unspoiled, untrammeled country is an essential natural resource itself, both for its PR value, as well as the benefits to a political economy the historical amnesia of these words brings. Turner surmises that each of the artists in *Hammertown* has a complex relationship, and resistance, to official representations of, and ideas about, landscape. To this I would add the artists' evocation of the disjunctive juxtapositions around ideas of the 'natural'. The word's double and triple meanings are poignantly evident in Canada, as they are in many colonized nations. Natural entitlements here are threaded within language describing a landscape of natural beauty. Imagery, especially of a vast, untouched wilderness, runs alongside aims of an immigrant citizenry hoping to cloak other claims to the land and its resources.

Sketch of the Boston
Courtesy of BC Archives, call no. A-07638

The works in *Hammertown* focus on the use of artifice. It is one of a number of tools the eight artists in the exhibition have developed independently of one another, and that are brought together here as an antipode to ideas about the natural. Things like the prop, the stereotype and the cheap commodity, low-res, childish and evidently contrived methods, and a repeated return to the joke occur throughout. These techniques set an ideologically laden 'natural' backdrop in sharp relief and are deployed as an argument for its ongoing reappraisal. More than critically reflecting a landscape, however, the works offer proposals. They are dialectic, and invite relationships that are collaborative and invitational. To this end the artists in *Hammertown* point to historical awareness that is embedded in acts of memory, not only to the scars on and of a landscape's repeated re-invention, but also to its rare traces of commitment.

FOOTNOTES

[1] McCullough, Michael, 'Stars', The Vancouver Sun, February 10, 2001 p. A14

[2] Bawlf, Samuel, *Sir Francis Drake's Secret Voyage to the Northwest Coast of America*, Ad 1579, Sir Francis Drake Publications, January 2001

[3] Debock, Matthew, '16,000 new jobs for BC economy: Robust retail, construction sector fuel the growth', The Vancouver Sun, August 10, 2002, p. A1

[4] Quoted in Stephen Hume, 'A Spanish Garden on the edge of our world...', The Vancouver Sun, March 7, 2002, p. A11

[5] Douglas, Stan, *Stan Douglas*, Phaidon Press, London, 1998, p 135

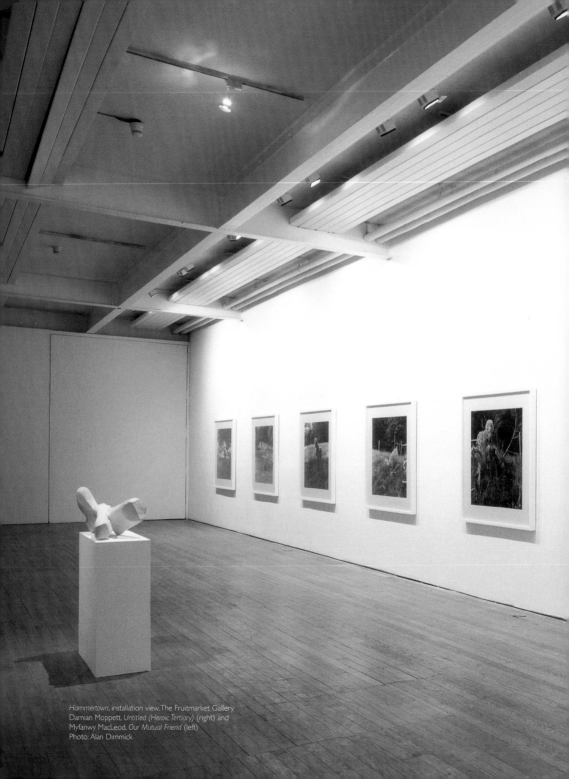

Hammertown, installation view, The Fruitmarket Gallery
Damian Moppett, *Untitled (Heroic Tertiary)* (right) and
Myfanwy MacLeod, *Our Mutual Friend* (left)
Photo: Alan Dimmick

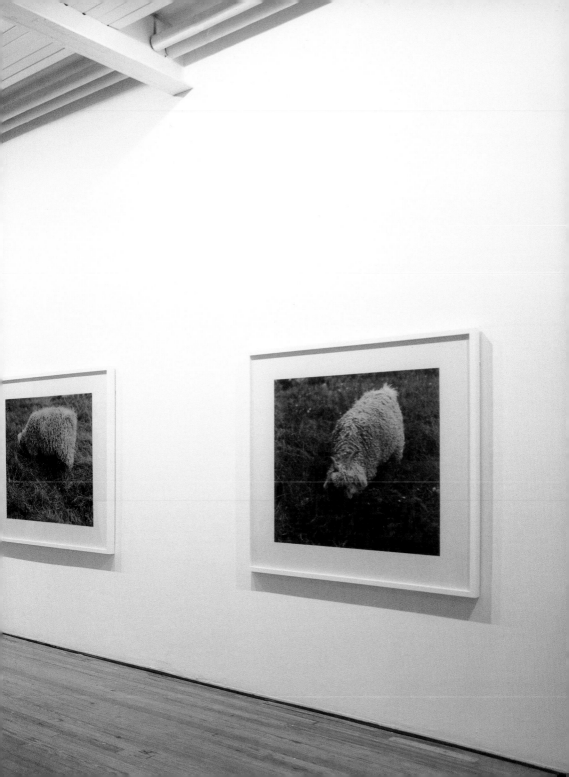

Artists' biographies

GEOFFREY FARMER
Born Vancouver, British Columbia, 1970
Lives and works in Vancouver

Education
1993 Emily Carr College of Art and Design, Vancouver, British Columbia
1991-92 San Francisco Art Institute, San Francisco, California

Selected Solo Exhibitions
2002 *The Blacking Factory*, Contemporary Art Gallery, Vancouver, British Columbia*
2001 Catriona Jeffries Gallery, Vancouver, British Columbia
2000 *Hunchback Kit*, Art Gallery of Ontario, Toronto, Ontario
1998 *Drawings*, Montgomery Fine Art, Vancouver, British Columbia
1996 *Home Alone (becoming your own spaceship)*,Or Gallery, Vancouver, British Columbia

Selected Group Exhibitions
2002-03 *Beachcombers*, Gasworks, London; Middlesbrough Art Gallery; Mead Art Gallery, University of Warwick, England
2002 *Officina America*, Villa delle Rose, Bologna, Italy*
2001 *Promises*, Contemporary Art Gallery, Vancouver, British Columbia
Solo Exhibition Space, Toronto, Ontario
Universal Pictures 3, Blackwood Gallery, Mississauga, Ontario
Universal Pictures 3.1, Plug-In Gallery, Winnipeg, Manitoba
The Alien Project, Edmonton Art Gallery, Edmonton, Alberta
2000 *Message by Eviction: New Art from Vancouver*, Illingworth Kerr Gallery, Calgary, Alberta

Self-Conscious, Catriona Jeffries Gallery, Vancouver, British Columbia
1999 Konstakuten Gallery, Stockholm, Sweden
Universal Pictures, Melbourne International Biennial, Australia*
Universal Pictures II, Monte Clark Gallery, Vancouver, British Columbia
1998 *Close Encounters*, Ottawa Art Gallery, Ontario
Belligeranti, Robert Birch Gallery, Toronto, Ontario
Fragile Electrons, National Gallery of Canada, Ottawa, Ontario*
Draaw, Stranger Draaw, Plug-In, Winnipeg, Manitoba
1997 *6: New Vancouver Modern*, Morris and Helen Belkin Gallery, Vancouver, British Columbia*
Big Dick Time, YYZ, , Toronto, Ontario
1995 *No Soy Pluto*, Medellin 57-4, Cuidad de Mexico, Mexico

BRIAN JUNGEN
Born Fort St. John, British Columbia, 1970
Lives and works in Vancouver, British Columbia

Education
1992 Concordia University, Montreal, Quebec
1992 Emily Carr Institute of Art and Design, Vancouver, British Columbia

Selected Solo Exhibitions
2003 Henry Art Gallery, Seattle, WA
Secession, Vienna, Austria
2002 Catriona Jeffries Gallery, Vancouver, British Columbia
2001 Contemporary Art Gallery, Vancouver, British Columbia*
Happy Medium, Art Gallery of Calgary, Calgary, Alberta

2000	Solo Exhibition Space, Toronto, Ontario
	Shapeshifter, Or Gallery, Vancouver
	Bush Capsule and Toronto Fieldwork, YYZ
	Artist's Outlet, Toronto, Ontario
2000	Dunlop Art Gallery, Regina, Saskatchewan
1999	Charles H. Scott Gallery, Vancouver, British Columbia*
1997	Truck Gallery, Calgary, Alberta

Selected Group Exhibitions

2002-03	*Beachcombers*, Gasworks, London; Middlesbrough Art Gallery; Mead Art Gallery, University of Warwick, England
2002	*Watery, Domestic*, The Renaissance Society Museum, Chicago, USA
	Bounce, Power Plant, Toronto, Ontario*
	New Modular, Blackwood Gallery, Mississauga, Ontario
2001	*ARS 01*, Kiasma Museum of Contemporary Art, Helsinki, Finland*
	Present Compose, Ottawa Art Gallery, Ottawa, Ontario
	Museopathy, Agnes Etherington Gallery, Kingston, Ontario
	Better Place, Mackenzie Art Gallery, Regina, Saskatchewan
	Windsor Art Gallery, Windsor, Ontario
	Long Time, Vancouver Art Gallery, Vancouver, British Columbia
2000	*Message by Eviction: New Art from Vancouver*, Illingworth Kerr Gallery, Calgary, Alberta
	Konstakuten Gallery, Stockholm, Sweden
1998	*Here and Now: First Nations Alumni*, Emily Carr Institute of Art and Design, Vancouver, British Columbia
1997	Or Gallery, Vancouver, British Columbia

EUAN MACDONALD
Born Edinburgh, 1965
Lives and works in Los Angeles, USA

Selected Solo Exhibitions

2002	Cohen Leslie and Browne, New York
	Dunedin Public Art Gallery, New Zealand
	Darren Knight Gallery, Sydney, Australia
	Galerie S.A.L.E.S., Rome, Italy
2001	James Van Damme Gallery, Brussels, Germany
	Jack Hanley Gallery, San Francisco, California
	Roberts & Tilton Gallery, Los Angeles, California
2000	Shaheen Fine Art, Cleveland, Ohio
	Galerie Zink, Munich, Germany
	Tracey Lawrence Gallery, Vancouver, British Columbia
1999	Canadian Embassy, Tokyo, Japan
	New Phase Art Space, Taiwan
	Robert Birch Gallery, Toronto, Ontario
	Four Walls, San Francisco, California
	Southern Alberta Art Gallery, Lethbridge, Alberta
1998	Or Gallery, Vancouver, British Columbia
	Oakville Galleries, Oakville, Ontario
1997	Art Gallery of Ontario, Toronto

Selected Group Exhibitions

2002	*Videodrome 2*, New Museum of Contemporary Art, New York
	Almost, curated by Regine Basha, Santa Monica, California, USA
	Gimme Shelter, Videos on Urban Discomfort, Museo Tamayo, Mexico City
	Gap Show, Museum of Modern and Contemporary Art Dortmund
	L.i.s.t. Gallery, M.I.T., Cambridge, Massachusetts, USA

2002 *BANG*, Canadianne Institute du Culture, Paris, France
In Szene Gesetze, Museum fur Neue Kunst zkm Karlsruhe, Germany

2002 *DV Noir,* California Arts Centre, Escondito, California, USA
Zero Arte Contemporanea, Milan, Italy

2001 Gallerie Zink Munich, Germany
Shelf Life, Gasworks Gallery, London, UK
Bluecoat Gallery, Liverpool, UK
S.A.L.E.S. Galleria, Rome
Orange Marble, Taipei, Taiwan
SFMOMA 010101, San Francisco, USA

2000 Platform Gallery, London, UK
Dave Muller 3 Day Weekend, The Approach, London, UK
Montreal Biennale, Montreal, Quebec
Fresh, New Museum of Contemporary Art, New York, USA

1999 *Altoids Collection,* Las Vegas, Chicago, Miami, USA
National Aviation Museum, Ottawa
The Time it Takes to Eat a Sandwich: Recent video Art from Canada, Depot Kunst und Diskussion, Vienna, Austria
Platform, London, UK

1998 *Version City,* Buffalo, New York
In Lieu, Toronto, Ontario
57 HOPE, Brooklyn, New York
Optica Gallery, Montreal, Quebec

1997 Floating Gallery, Winnipeg, Manitoba
Waiting For Something to Happen, Toronto, Ontario
Anderson Gallery, Buffalo, New York, USA

1996 Gallery 101, Ottawa, Ontario

1995 Mercer Union, Toronto, Ontario

LUANNE MARTINEAU

Born 1970 Saskatoon, Saskatchewan
Lives and works in Victoria, British Columbia

Education

1995 University of British Columbia
1993 Alberta College of Art and Design
1992 Nova Scotia College of Art and Design

Selected Solo Exhibitions

2002 Medicine Hat Museum & Gallery, Medicine Hat, Alberta

2001 *Lubberland,* Stride Gallery, Calgary, Alberta

2000 *Saskadiaspora 2,* Dunlop Art Gallery, Regina, Saskatchewan*

1999 *McFadden's Flats,* Truck Gallery, Calgary, Alberta; Gallery 101, Ottawa, Ontario
Hogan's Alley, Optical multi-media project room, Montreal, Quebec

1998 *Ryan's Arcade,* Mercer Union, Toronto, Ontario
Love Letters to the Shiv Artist, Eye Level Gallery, Halifax, Nova Scotia; Struts Gallery, Sackville, New Brunswick

1997 *Ryan's Arcade,* Or Gallery, Vancouver, British Columbia

1996 *Buttermouth,* The New Gallery, Calgary, Alberta

Selected Group Exhibitions

tba *Death, the Experience,* Plug In Inc., Winnipeg, Manitoba

2002 *Suggestive Line,* Belkin Satellite, Vancouver, British Columbia
Fabricator, Hodson Gallery, Hood College, Frederick, Maryland, USA
Alberta Biennial, Edmonton Art Gallery, Edmonton, Alberta*
Playful Thoughts, Paul Kuhn Gallery, Calgary, Alberta

2001 *10x2: Dwelling,* Victoria School, Edmonton, Alberta

1999 *AFA: Selections From The Collection,* Illingworth Kerr Gallery, Calgary, Alberta

1998	*Montreal-Calgary*, Circa Gallery, Montreal, Quebec
1996	*Residue*, Truck Gallery, Calgary, Alberta
1995	*House of Cruelty*, Columbus
	Group Drawing Exhibition, Or Gallery, Vancouver, British Columbia

DAMIAN MOPPETT
Born 1969 in Calgary, Canada
Currently lives and works in Vancouver, British Columbia

Education
| 1995 | Concordia University, Master of Fine Arts, Montreal, Quebec |
| 1992 | Emily Carr College of Art and Design, Vancouver, British Columbia |

Selected Solo Exhibitions
2000	*Impure Systems*, Catriona Jeffries Gallery, Vancouver, British Columbia
1997	Trepanier Baer Gallery, Calgary, Alberta
1996	Access Gallery, Vancouver, British Columbia
1994	Espace #502, Montreal, Quebec
1992	Perel Gallery, Vancouver, British Columbia

Selected Group Exhibitions
2003	*Photographic Terrain*, Canadian Museum of Contemporary Photography, Ottawa
2002	*Bounce*, Power Plant, Toronto, Ontario
	New Modular, Blackwood Gallery, Mississauga, Ontario*
	Provisional Worlds, Art Gallery of Ontario, Toronto, Ontario*
	Heterosexy, Gallerie B-312, Montreal, Quebec
2001	*Painter Editions, Recent Projects: Peter Doig, Valie Export, Richard Hawkins, Mike Kelley, Damian Moppett, Richard Prince,*

	Ed Ruscha, Patrick Painter Inc., Santa Monica, California
	These Days, Vancouver Art Gallery, Vancouver, British Columbia
	Long Time, Vancouver Art Gallery, Vancouver, British Columbia
2000	*Message by Eviction: New Art From Vancouver*, Illingworth Kerr Gallery, Alberta College of Art and Design, Calgary, Alberta
	Image and Light, History and Influence: Film and Photographic Works, Vancouver, C.H. Scott Gallery, Vancouver, British Columbia
	Self-Conscious, Catriona Jeffries Gallery, Vancouver, British Columbia
	Shoot! A Covert Optimism in New Vancouver Art, Kenderdine Gallery, Saskatoon, Saskatchewan
	Recollect, Vancouver Art Gallery, Vancouver, British Columbia
	Copycat, Kenderdine Gallery, Saskatoon, Saskatchewan
	The High Life, Monte Clark Gallery, Vancouver, British Columbia
	Blind Man's Bluff, Toronto Photo Workshop, Toronto, Ontario
	Lunch Money, Art Gallery at Mount Saint Vincent University, Halifax, Nova Scotia*
1998	Or Gallery, Vancouver, British Columbia
	Trepanier Baer Gallery, Calgary, Alberta
	6: New Vancouver Modern, Morris and Helen Belkin Gallery, Vancouver, British Columbia*
1997	*Primary Colours*, Galerie Barbara Farber – Rob Jurka, Amsterdam, Netherlands
	Bonus, Canadian Museum of Contemporary Photography, Ottawa, Ontario; Contemporary Art Gallery, Vancouver, British Columbia*

| 1997 | *Disrepresentations*, Edmonton Art Gallery, Edmonton, Alberta |
| 1996 | *Between Painting and Photography*, Trepanier Baer Gallery, Calgary, Alberta |

SHANNON OKSANEN
Born 1967
Lives and works in Vancouver, British Columbia

Education
Studied at the University of British Columbia

Selected Solo Exhibitions

2002	*Spins*, Or Gallery, Vancouver, British Columbia
1999	*Pale Movie*, VTO Gallery, London, England
1998	*We're All Stars Now*, Dunbar Gallery, Vancouver, British Columbia
	Stay, Robson Street Gallery, Vancouver, British Columbia*
1997	*Cells and Stills*, Trylowsky Gallery, Vancouver, British Columbia

Selected Group Exhibitions

2001	*These Days*, Vancouver Art Gallery, Vancouver, British Columbia
	Pause and Play, VTO Gallery, London, England
2000	*Octoberfest*, VTO Gallery, London, UK
1999	*Caught*, 303 Gallery, New York, USA
	Sexy Girl, Charles H. Scott Gallery, Vancouver, British Columbia
	Universal Pictures, Monte Clark Gallery, Vancouver, British Columbia
1997	*Exquisite Cadaver*, Presentation House Gallery, Vancouver, British Columbia
	Browser, The Roundhouse, Vancouver, British Columbia
1996	*Framed*, Or Gallery, Vancouver, British Columbia

| 1995 | *Wall to Wall*, Or Gallery, Vancouver, British Columbia |

KEVIN SCHMIDT
Born 1972
Lives and works in Vancouver, British Columbia

Education

| 1997 | Bachelor of Fine Arts, Studio, Emily Carr College of Art and Design, Vancouver, British Columbia |

Selected Exhibitions

2003	*Small Waves, Cold Water*, Access Artist-Run Centre, Vancouver, British Columbia
2002	*Satan, Oscillate my Metallic Sonatas*, Contemporary Art Gallery, Vancouver, British Columbia
	Voir Grand, Sadie Bronfman Centre, Montreal, Quebec
	Curatorial Market, Cuchifritos, New York
2001	*Our Favourite Places*, False Creek Community Centre, Vancouver, British Columbia
2000	*Out of Sight*, Surrey Art Gallery, Surrey, British Columbia*
1999	*Edge City*, Surrey Art Gallery, Surrey, British Columbia*
1997	*Suburbia*, Helen Pitt Gallery, Vancouver, British Columbia

* *Denotes catalogue*

List of Works in Exhibition

Geoffrey Farmer
Trailer, 2002
Steel, fibre board and mixed media
3.4 × 2.2 × 9m

November 19, 2001 Vancouver Canada
Single channel video from DVD
Duration 5 mins, looped
Both courtesy Catriona Jeffries Gallery

Brian Jungen
Beer Cooler, 2002
Picnic Cooler, beer
40 × 70 × 40cm
Courtesy Catriona Jeffries Gallery

Euan Macdonald
The Shadows Path, 2002
Single channel video projection from DVD
Duration c. five minutes

Two Lions, 2002
Single channel video from DVD
Duration c. five minutes

Untitled, 2002
Acrylic on paper
40 × 50cm
All courtesy the artist

Myfanwy MacLeod
Our Mutual Friend, 2002
Wooden carved sculpture
24" × 10"
Courtesy Catriona Jeffries Gallery

Luanne Martineau
The German General, 2002
Felt, mohair, fabric, styro-beads
4 × 3.5 × 9 feet (approx)
Fabrication by Quynh Chestnut
Courtesy the artist

Damian Moppett
Untitled (Heroic Tertiary), 2002
8 framed Fuji crystal archive prints mounted to board
Each 48 × 48"
Courtesy Catriona Jeffries Gallery

Shannon Oksanen
Spins, 2002
16mm film projection
Duration 3.5 mins
16mm film, looper mechanism,
16 mm film projector
Courtesy the artist

Kevin Schmidt
Long Beach Led Zep, 2002
Single channel video from DVD
Duration 10 mins, looped
Camera Operator: Aniko Fenyvesi
Boom Microphone: Phil Dion
Courtesy the artist

sponsored by
STANDARD LIFE INVESTMENTS

Hammertown is a touring exhibition organised by The Fruitmarket Gallery in association with the Contemporary Art Gallery, Vancouver.

The Fruitmarket Gallery, Edinburgh
5 October to 23 November 2002

Bluecoat Gallery, Liverpool
Dates to be confirmed

Winnipeg Art Gallery, Ontario
29 October 2003 to 4 January 2004

Major exhibition sponsor:
Standard Life Investments

The Fruitmarket Gallery and Contemporary Art Gallery acknowledge the support of the Department of Foreign Affairs and International Trade of Canada, The Canada Council for the Arts and the Province of British Columbia through the BC Arts Council. Avec l'appui du Ministère des Affaires trangères et du Commerce international du Canada.

Assistance for research into and initial production of this exhibition was provided by the Canada Council for the Arts through its Production Assistance Program.

Publication designed and typeset by Juliet Knight in association with Reid Shier and the artists.

Published by The Fruitmarket Gallery
45 Market Street, Edinburgh EH1 1DF

The Fruitmarket Gallery is subsidised by the Scottish Arts Council
Scottish Charity No. SC 005576

Catalogue printed in an edition of 500 copies by Specialblue, London. Printed in the UK

ISBN 0 947912 38 X

In planning the *Hammertown* project, we received advice, support and practical assistance from many different individuals and organisations. We would particularly like to thank the following: Reid Shier, Catriona Jeffries, Diana Jervis-Read, Michael Regan, Sandy Crombie, Fiona Fowler, Tanja Gertik, Michael Turner, Johan Shaw, Jackie Lennie, Lyndsay McLellan, Jane Campbell, Iain Shaw, Scott Cadenhead, all the artists, the staff and installation team at The Fruitmarket Gallery.